IMAGES
of America

MAGALIA TO
STIRLING CITY

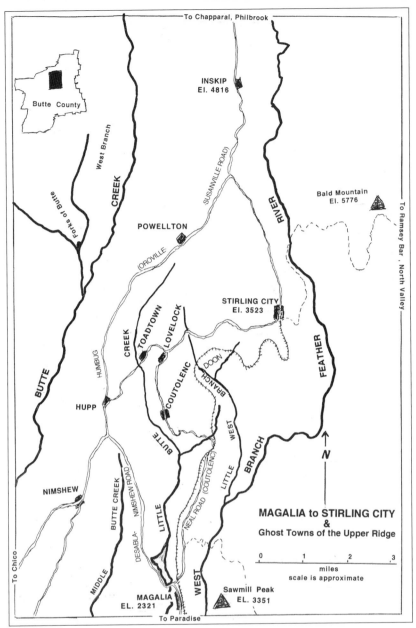

The map above shows the mining and lumbering areas of Butte County.

ON THE COVER: This early photograph of the Diamond Match Company's Stirling City Sawmill was taken sometime before the fifth boiler and smokestack were installed in 1913–1914. Note the curved slipway, up which logs move from the mill pond into the mill. The sawmill was built in 1904 and operated until 1958, when it was supposed to be scrapped but was destroyed by a mysterious fire. Supposedly some old-time loggers and mill hands thought that this spectacular fire was a more appropriate end for the old mill. The railroad track on which the men are working appears to be standard gauge and likely is the beginning of the railroad to such logging camps as the one at Bottle Creek north of Stirling City.

IMAGES
of America

MAGALIA TO
STIRLING CITY

Robert Colby and Lois McDonald

ARCADIA
PUBLISHING

Published by Arcadia Publishing
Charleston SC, Chicago IL, Portsmouth NH, San Francisco CA

Printed in the United States of America

Library of Congress Catalog Card Number: 2005926401

For all general information contact Arcadia Publishing at:
Telephone 843-853-2070
Fax 843-853-0044
E-mail sales@arcadiapublishing.com
For customer service and orders:
Toll-Free 1-888-313-2665

Visit us on the Internet at www.arcadiapublishing.com

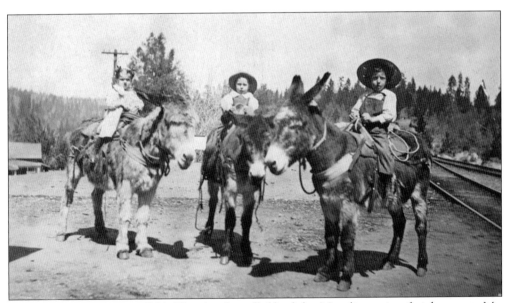

Burros were common in 1904. The daughter (left) of the Magalia station freight agent, Mr. Rice, rides with her friends. They are Oliver Warren, son of Annie and Ed (center); and George Burnside, son of Lottie Burnside.

CONTENTS

ACKNOWLEDGMENTS

The majority of images reproduced in this book were taken by amateurs who enjoyed recording life around them. For more than 40 years, many of these individuals donated pictures that were published by Paradise Fact and Folklore in *Tales of the Paradise Ridge*. Those whose pictures are used in this book are Hazel Duensing, Lloyd Sewell, Ernestine Bach, Melissa Polk, Winslow Lovett, Madge Wright Ryan, Elsie Hamburger, Garrett Starmer, R. M. Brown, Charlton Collett, Delia Archer, Ralph Hupp, and the Bishop family. These pictures were part of the Fact and Folklore collection that is now in the Gold Nugget Museum and History Center archives. Several large collections were made available to the authors, including that of Annie Warren, which also is now part of the museum archives. The Florence Styles collection is divided between the Gold Nugget Museum and the Paradise Genealogical Society.

Others who have furnished pictures are Bill Shelton from the Dana Bailey family albums, Carol Lewis from the Lucian Vandegrift collection as well as from her own, Bob Pearce from the Pearce family, Madelyn Henry from the Horton family, Marilyn Brakebill Meyer from the Brakebill family, Marylee Hupp Woods from the Hupp family, Allen Knotts, Rosella Velliquette, Kent Stephens, June Beavers Yount, and Nancy Rogers. The Paradise Irrigation District has been generous in its loan of pictures. Thanks to Connie Rogers of the Gold Nugget Museum for a large number of images scanned from the museum collection and to Chuck Smay for his technical assistance with scanning slides.

Bob and Lois thank them all and beg the pardon of any we may have inadvertently omitted. The more than 90 issues of *Tales of the Paradise Ridge* (1960–2005) have proved to be a bottomless well of historical information.

One

DOGTOWN-MAGALIA

The prehuman history of this Sierra foothill community is far more dramatic than what has happened in the last 154 years. It would have been unsafe for human beings to have witnessed the eruption of the southernmost peak in the Cascade Range, but it would have been exciting to have seen the great rush of material fill in those rivers that once were flowing freely into the inland sea—a sea that backed up to our town of Magalia some million years ago.

The miners that arrived with the California gold rush were canny in following the signs of gold and finding the precious metal that had formed in those river beds hundreds of feet below the surface. Still, the job would have been so much easier for them had the prehistoric stream beds not been choked with mud, gravel, and lava. Better yet, we could still be taking out treasure that remains inaccessible today.

The first of the gold seekers came in 1849 up the canyon of the west branch of the Feather River, or they followed Butte Creek and its several branches. Climbing up from the canyons, they came together in a small saddle between the streams. Here a tented trading post was erected by one man as an easier way to make money—taking it from the hungry, ill-clad miners rather than from the cold wet streams. Flour, sugar, coffee, and tobacco were hauled by mules and wagons from Marysville or farther. A sawmill or two followed. Saloons appeared, and so did more stores, hotels, and horse stables.

Few women came in the early 1850s, but one miner's wife, who had insisted on coming herself and bringing a dog or two on the trip across the plains from Iowa, did not miss the glint of joy in the eye of every lonesome miner who spotted her mongrel puppies cavorting among the tent houses. Sales were brisk for Susan Bassett. As the reputation of the town grew, the name Dogtown naturally came to the miners' lips, and the name of the town was set.

For a short while, the community had a post office called Butte Mills, chosen no doubt (as was Sawmill Peak for the local mountain) for the presence of small water-powered sawmills that produced wood for shelters or timbers for supporting mine shafts. The office closed (probably the postmaster left town for a hot claim), but in 1857, when the town had grown large enough to attract the polished and ambitious young Dr. Buffum, who came seeking to establish a practice, the doctor applied to the U.S. Postal Department for another.

The townspeople could not believe the name of the post office that was to represent their town: Magalia. What or who was a Magalia? Had the doctor grown mad, or had he perhaps forgotten how to spell Magnolia?

Over the years, the residents of the mining town grew to accept Magalia, but only reluctantly. Even today, 98 years later, grumbling persists. In 2005, the post office has been moved to the new center of a population that grew after 1970, when a huge subdivision of cut-over forest land was sold in house lots north of town. It has since become inhabited by retirees from all over California, some of whom are enchanted with the local history and requested the postal folks to rename the local post office Dogtown.

Perhaps it is as strange to live in Paradise Pines and get mail at the Magalia Post Office, as it was to live in Dogtown and have a Latin name of who-knows-where on the envelopes addressed by the folks back east.

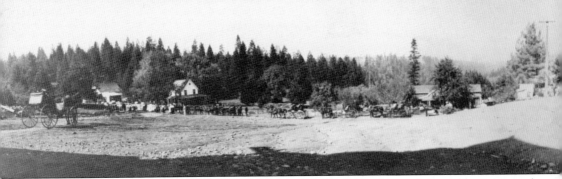

Without the love of community and family shared by early residents of the gold-mining and logging towns of northern Butte County, we would not have this image of a funeral train leaving the service of "Mother" McLain and escorting her coffin up the hill to the Magalia Cemetery.

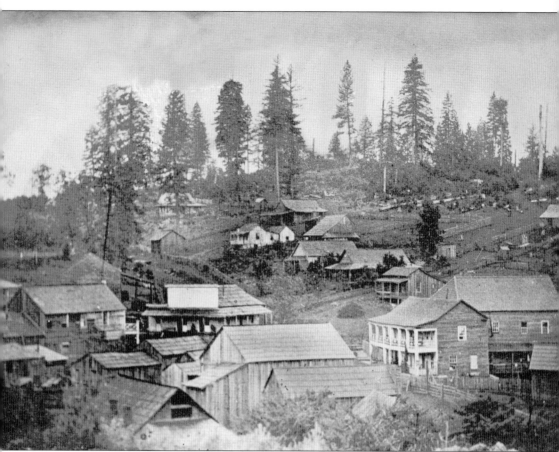

This is Dogtown before the major fire of 1870. The photographer stood high up on the serpentine granite hill that still defines the northern limits of Magalia. Today's Skyway cuts through the western part of the hill. Looking south-southwest at the town, it lies in a natural saddle between Little Butte Creek on the right and the canyon of the west branch of the Feather River on the left. Several of the buildings are hotels. The Baders had a brewery. There are several stables, at least one butcher shop, and numerous saloons. The town fit snuggly into the area between the one signal light of today, the hill up into Magalia, the Neal Road (today's Coutolenc Road), and the slope toward Butte Creek where, during Dogtown days, the Chinese had their homes. After the fire, which nearly wiped out the town, businesses and residents alike began moving up the hill to rebuild. They accepted Magalia as the name of the reborn town.

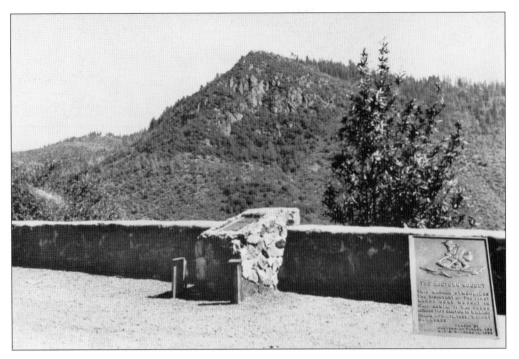

Sawmill Peak, from whose flanks the famous Dogtown Nugget was washed by a hydraulic monitor, is both mascot and sentinel to Magalia. The above photograph was taken from the east side of "main" street. The stone wall and base for the plaque were donated by the Native Daughters of the Golden West, Parlor No. 295, in April 1959. It says, "The Dogtown Nugget. This marker symbolizes the discovery of the first large gold nugget in California. It was found across this canyon on the Willard Claim April 12, 1859 —Weight 54 pounds." Below is a model of the famous nugget, based on the memories of several persons who saw it. The actual nugget, judging by a water-replacement test conducted by Bob Colby, was larger than the image by four times or more.

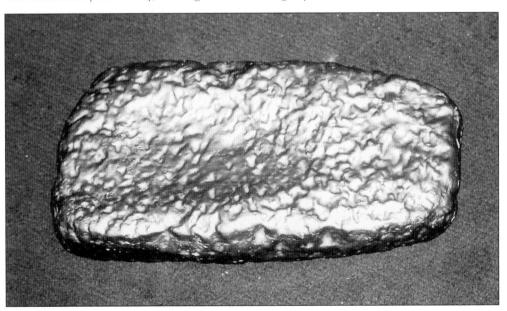

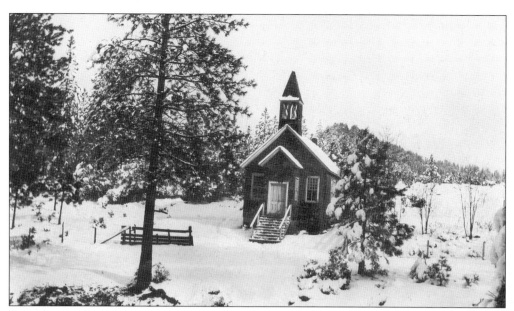

Every year, snow casts a pure mantle over the otherwise shabby buildings in Magalia. The church, with Sawmill Peak in the background, must surely have been an inspiration to the local people when they saw it thus. Construction of the little building was started in Dogtown about 1894, and the church was moved, still without a roof, to the site on the hill. The building is on the National Register of Historic Buildings. It is still used for worship each Sunday.

The self-appointed conscience of Magalia was Miss Carrie Brydon, a Canadian spinster who came to live with a cousin when she developed a consumptive cough. Her cousin turned out to be the town's drunken blacksmith, which sent Miss Brydon off to find her own little house. She enlisted the help of the Women's Christian Temperance Union in Chico. Mrs. Annie Bidwell helped complete the church building and donated the organ. Miss Brydon taught the Sunday school class.

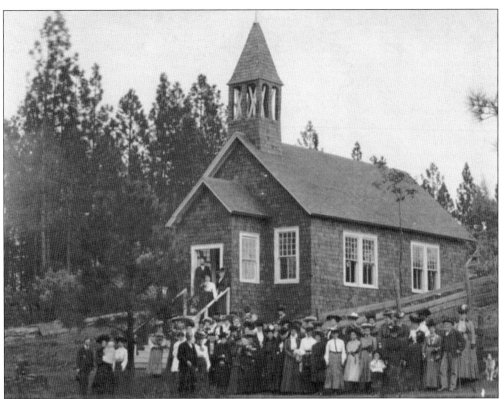

At Easter in 1909, the Magalia Church was dedicated. The long interval between its beginning in 1894 and its completion may be attributed to both a recession in the mining industry and a temporary lack of leadership. The latter need was filled by the arrival of Carrie Brydon. Benefactress Annie Bidwell of Chico is the hatted lady on the porch. The interior of the church (pictured below) showed the many hours of loving care lavished by the ladies of Magalia, with a carefully decorated Easter theme. The stove pipe extends to the ceiling on the right.

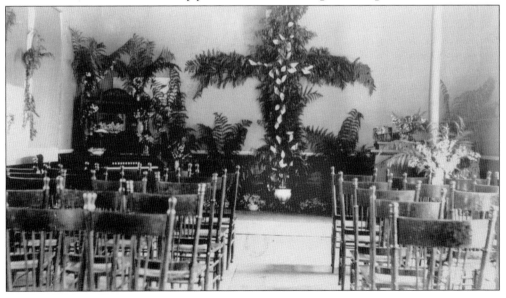

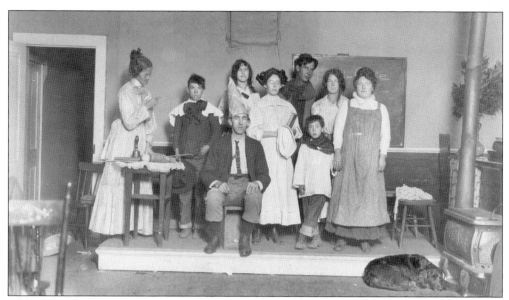

The church was used for many community purposes, as churches have always been the social centers of small communities. *The Country School*, a play, is seen here being enacted. Mrs. Bjorn portrayed the scolding teacher. To Emery Satterlee fell the role of dunce, with his wife Bertha, Clara Batman, and Etta Moore among the student body. Annie Warren is at right, holding the hand of her son Oliver. The Warrens' dog Sport was also featured.

The eyes of Magalia were those of Emery Satterlee, kept busy by his hobby of photography. The Satterlees, Emery and Bertha, came to Magalia in 1908. He was both the railroad freight agent and the bookkeeper for Levi Cohn, the storekeeper who displayed Satterlee's postcards for sale. Emery weighed the gold dust traded by miners for supplies, and he kept an account of money credited to them.

This photograph shows Magalia as one enters from the south. The main street through town was only six-tenths of a mile long, and it had a hill at each end. Ascending the hill on the south, the first view would be Bader's rental cottages on the left and Magalia Hall on the right. Dogs and children played freely in the streets, scampering to one side as a horse or carriage appeared.

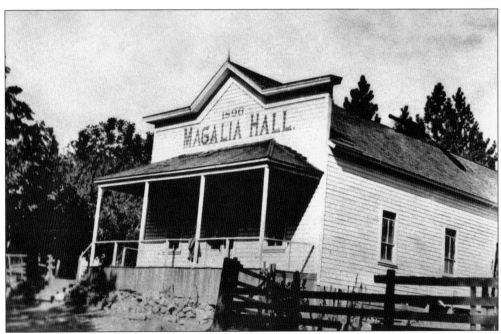

Magalia Hall was built by Charles Bader, a prominent Magalia hotel keeper. He made it an adjunct to his hotel. One might call it the convention center of Magalia. The unmarried schoolmarm who boarded at the hotel was always provided escort service from building to building under the covered walkway.

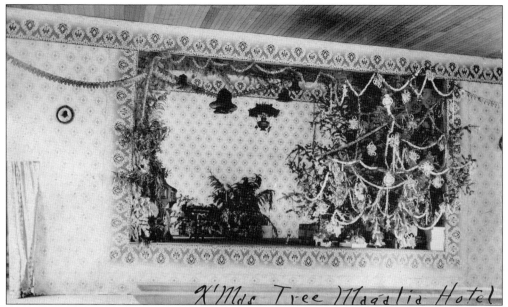

X'Mas Tree Magalia Hotel

The hotel staff decorated Magalia Hall for many special occasions. This 1909 Christmas display included kerosene lights, strings of popcorn festooning the native tree, homemade snowflakes, and brightly clad paper soldiers. On the far left, the stairs to the stage are barely visible.

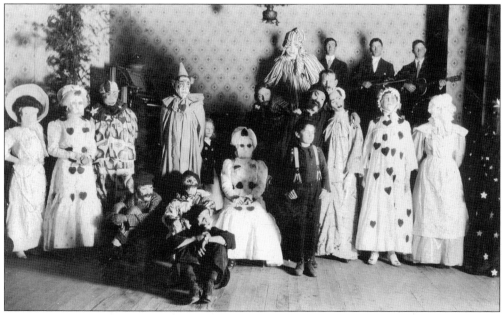

A costume ball! What shy maiden hid herself behind a homemade mask, nervously trembling lest her true love not recognize her? Male disguises seem to have relied heavily on mustachios. It was customary to dance until nearly dawn and then move to the hotel dining room for a hearty breakfast before going home as the sun rose. Music for this ball was provided by the Knox boys: Clyde and his twin brothers, Edward and Edgar.

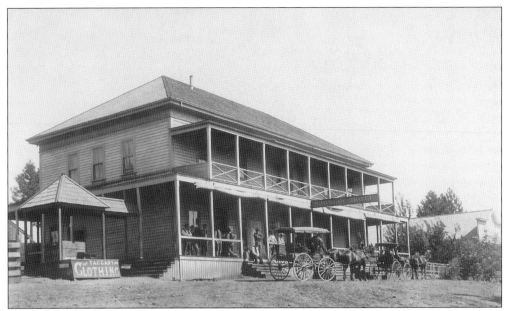

The Bader Hotel offered Magalia's most luxurious accommodations. This was the third of three Bader Hotels, built in 1895, all of which were destroyed in fires. The hotel was patronized by mining engineers and speculators. Many came up from the hot, malaria-prone valley towns for health reasons. There was no central heating, but hot water bottles came with the room as well as chamber pots. The usual facilities were up the small hill to the rear.

In 1909, Mr. and Mrs. Dawson were the hotel managers. They pose here with their Greek cook, whose rolling pin suggests he was working on a pie when he was interrupted. It was his job to stoke the fire with wood, keep coffee fresh and hot, and bake the cakes and pies when roasts of beef venison or pork were not in the oven.

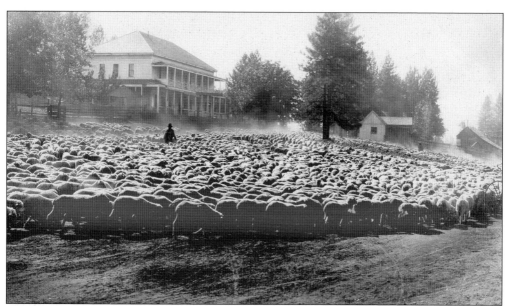

Strange and marvelous sights awaited the hotel guests in spring or fall when herds and flocks were moved between high meadow pastures and the valley. The drovers' road ran through Magalia's main street. From the clouds of dust and the fact that the sheep are headed south, it is not hard to surmise that this is the autumn of the year. Is that a shepherd amongst the flock or a hapless pedestrian caught trying to cross the street?

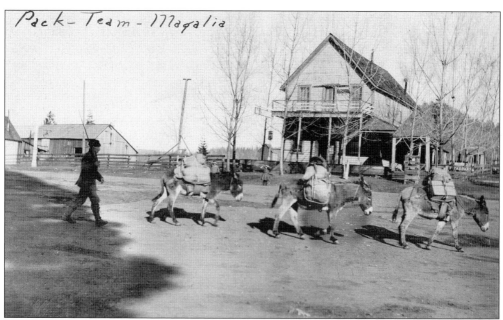

Magalia had several inns or boardinghouses, including this one just north of the Bader Hotel. It was run for some years by Annie Warren. Notice the children on the far side of the street. Are they more captivated by the miner leaving town for his isolated mine with a six-month supply of flour, bacon, and coffee or by Emery Satterlee and his camera on the west side of the street?

This scene of Magalia's "commercial" area was snapped by Emery Satterlee from the roof of the Bader Hotel. On the left is the emporium owned by Levi Cohn (and his father Hirsch Cohn before him). Dry goods, groceries, and mining hardware had their niche somewhere, including a large basement. Next to the emporium (right) is a building housing Foster Perry's barbershop and Ed Warren's saloon.

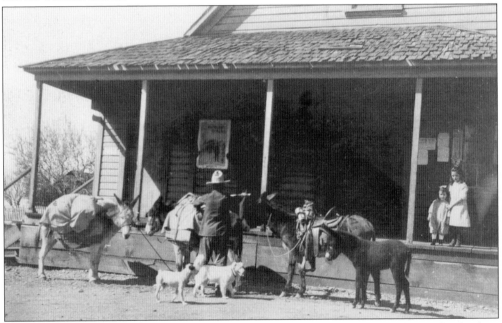

Cohn's market attracted the single miners who came with burros to carry their supplies back to the mine. Larger, more accessible mines had delivery service from Cohn. He gave liberal credit to them all. Cohn's small daughters Hortense and Norma Frances watch with fascination from the porch. Their mother, Bertha Mendelssohn Cohn, was from San Francisco and did not permit them to play in the street, let alone pet that cute little dusty burro who wouldn't stay behind at the mine.

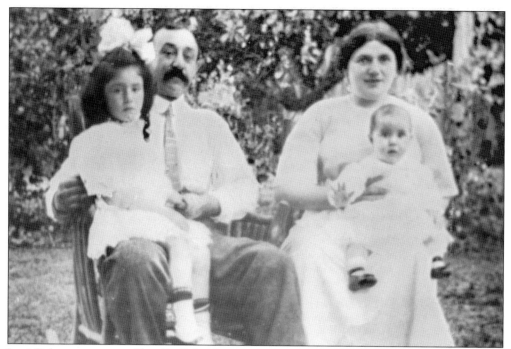

Levi Cohn was respected by all of Magalia's residents, so far as history reveals. He was Jewish, as were many of the Europeans that were attracted to the California gold rush—like Levi's father, Hirsch. There is no evidence of racial bias in Magalia. The Jews always sought a member of their own faith to marry. Levi was late in marrying, having so little time as a youth to seek a bride. Bertha gracefully accepted life in a rural area but forbade her children to go to the local school. She and the children lived in Chico much of the year. Levi is holding Norma Frances, and Bertha, Hortense.

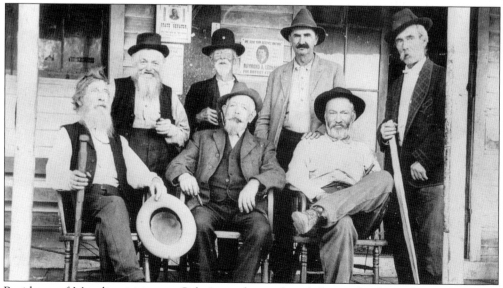

Residents of Magalia visiting on Cohn's porch are, from left to right, (seated) Joseph Moore, father of Annie Warren; Tom Mugford; and Frank Eckert; (standing) Charlie Andrews; Harry Williams; Constable Bill Ware; and Alex Girard.

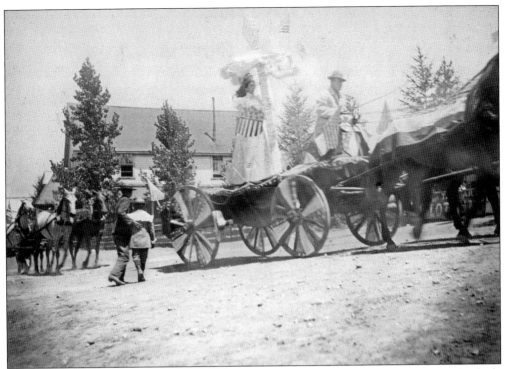

Somewhat faded from the passage of 106 years, this 1902 photograph of Magalia's Fourth of July parade shows Mabel Bader representing the "Goddess of Liberty." Not every ridge town celebrated the Fourth of July every year.

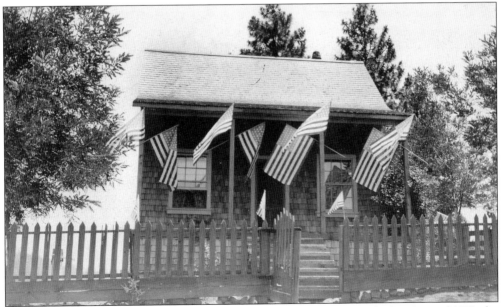

When it came Magalia's turn, everyone went all out in showing patriotic display. Around 1910, the Satterlees used flags generously to enliven the appearance of their brown-shingle, rented home.

Just beyond Warren's saloon to the north was another hotel, Myers Hotel, which was operated by the Langwiths in 1909. In February 1923, this building burned in a fire that took the west side of Magalia. It started in a house to the right of the hotel in a faulty flue. Aided by the north wind and the fact that pipes were frozen in an unnatural cold spell, the fiery destruction could not be averted.

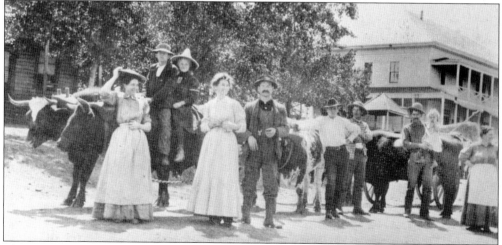

The roadway through Magalia was wide—much wider than the narrow turn from the railroad station. A load of heavy freight and several span of oxen had to drive up into central Magalia to turn around to go up either road north from the station. The event turned into a social gathering as children, housewives, and workers came out to enjoy the sight.

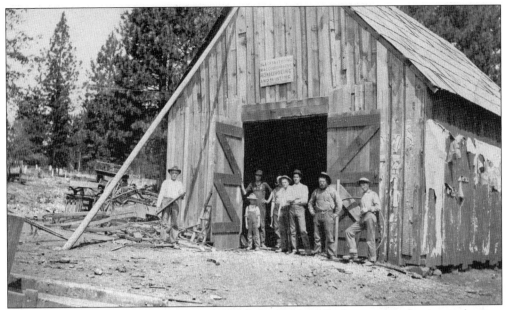

As the road began to slope off on the north hill, the blacksmith shop occupied a site on the west side, not far from the Magalia Cemetery (at left in the background). A smithy was an absolute necessity for a mining area. The blacksmith also became the town mechanic as the automobile age began. The smith in this 1909 picture is Robert MacDonald (left).

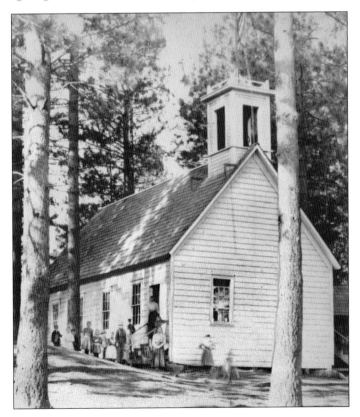

The Magalia schoolhouse, in a play area full of tall pines, was for years north of the smithy. One of the school buildings was flattened by a tree falling during a windstorm one night. A new building just like it was erected. Madge Wright, the teacher for several years, is standing in the doorway of the building. The land today is an extension of the Magalia Cemetery.

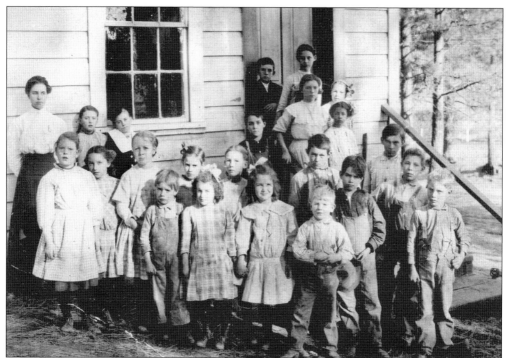

This is the 1909 or 1910 summer session at the Magalia School. The younger children often went to school only in the summer, when the roads were not muddy. Those pictured here, from left to right, include (first row) Eva Hendrix, Bessie Keller, Phoebe Adams, Allen Stanley, Dennie Perry, Frances Adams, Ernie Hendrix, and unidentified; (second row) Miss Wright, Susie Hendrix, Erma Anderson, Florence Stanley, Arthur Starkey, Joe Stanley, and Cloyd Pearce; (third row) Oliver Warren and Clara Batmen.

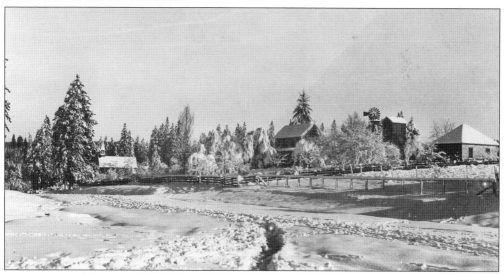

Across the road from the smithy and the school in Magalia were the church and the Perry home. It was one of the grander homes in Magalia but most noteworthy for its windmill that filled the house's water tank with no human effort. In the brick house on the far right lived Foster Perry, a son and the town barber.

Annie Moore Warren and her husband, Oliver Edward "Shorty" Warren, are seen in a later photograph. Annie embodied the heart of the Magalia community and served as its memory and our benefactor through her scrapbooks. From her arrival in Dogtown at age four until her death at 96, she lived for the betterment of family and friends. One of her major undertakings was the marking of graves in many upper ridge cemeteries where stones had never been placed or had been destroyed by fire and time. Tens of concrete markers, curved at the top and stamped with names while the concrete was wet, can be found in both established and wayside burial sites today thanks to Annie Warren.

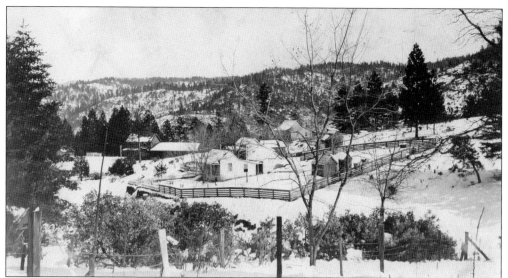

In over 100 years, the trees have rewooded the north Magalia slope. In 1910, Ed and Annie Warren owned the fenced-in little farm cleared on the hillside. Although a carriage road was available, the Warrens used the steps that took them from their yard down to the main road. Whether to school, Ed's saloon, or Annie's hotel, the walk was a short one.

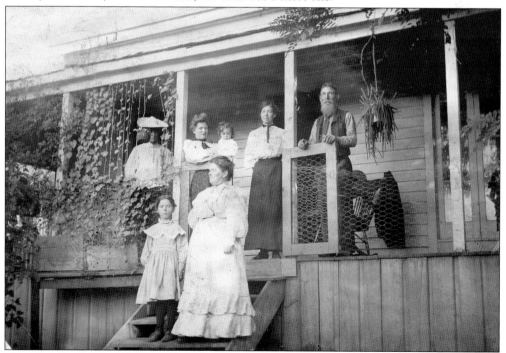

Next door to the north was a home Annie claimed was the oldest one in Magalia during her lifetime, built in 1860 and lived in for a while by the Warrens after their marriage. Notice the chicken wire fence on the porch, the hanging "donkey tails" plant, and the vines growing from wooden crate planters. Annie holds her son Oliver. Next to her is her sister Ida Moore (Burleson) on her left. Mr. Moore is the only man. Annie's mother, Bridget, stands on the steps with Etta Moore (Larrimore).

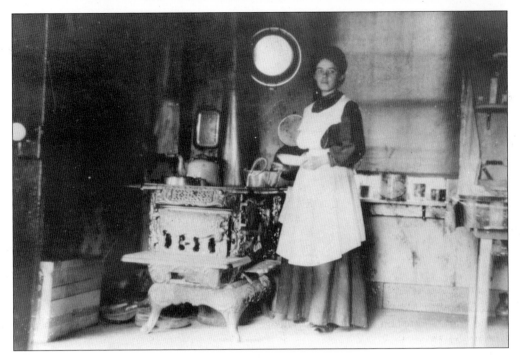

The Satterlees honeymooned in Magalia, living in a small house they rented not far from the railroad station. Emery never wearied of recording scenes of their domestic happiness, thus one can share the 1910 kitchen with Bertha, noticing that she hung the dishpan over the wood stove, or perhaps that was bowl in which she kneaded bread. Her worktable and its oilcloth cover is on the right. Below is the dining room—most likely just the opposite side of the kitchen from the range. The sideboard holds the Satterlee's dishes, with a pretty piece of china shown off on top. The Satterlees are eating dinner alone.

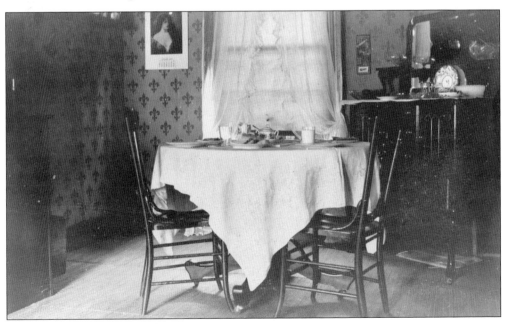

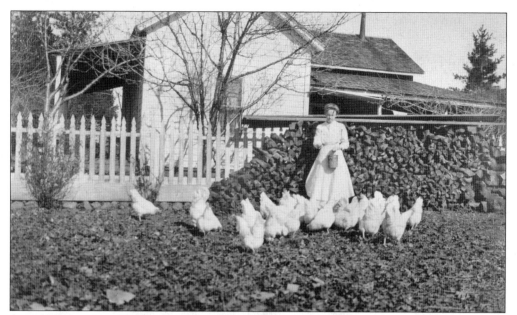

Annie Warren jotted on the back of this image that Mrs. Satterlee is feeding Mrs. Bohlander's chickens. It was a neighborly thing to do, and Emery Satterlee thought it was a pretty sight to capture with his lens. The Bohlander house sat on the edge of the canyon looking down at the railroad tracks.

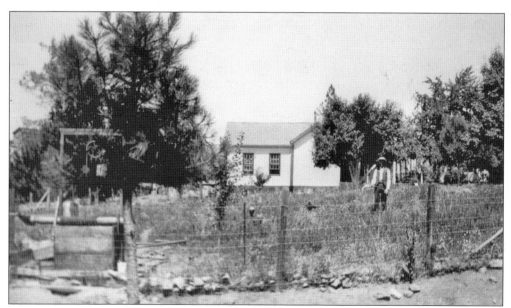

By 1912, when this picture was taken, only the Mclains still owned what they referred to as a little "ranch" where old Dogtown had stood. George Mclain is heading toward the community well, with its chain and bucket. George had a slaughter house and ran a butcher shop on the west side of the hill. His brother Lou had a grocery store there when he was young.

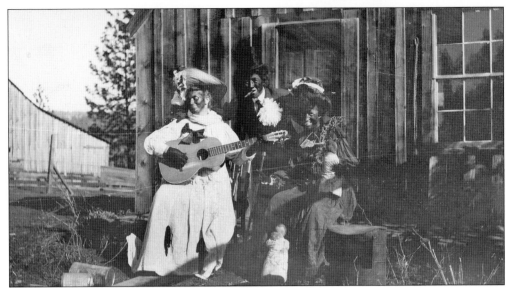

Many remember Magalia as a happy town where folks made their own amusements. Mable Roney, Mrs. Pfister, and Lottie Burnside had no idea they would someday be judged politically incorrect. They were practicing their own version of the very popular blackface minstrel shows of the 19th century.

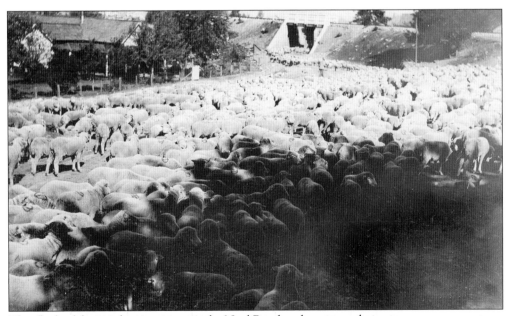

This flock of sheep is leaving town on the Neal Road underpass on their way to summer pasture. Yes, this is a spring sight—no dust yet on the road, and it is the season for moving livestock north. The McLain homestead is on the left.

Two

THE BUTTE COUNTY RAILROAD

In 1902, the owners of property up the lava ridge east of Chico were puzzled by the sudden interest in their nearly worthless land. They had not known of the recent quiet cruising of timber lands at higher elevation by the Diamond Match Company of Wisconsin. When Diamond's buyers came into what is now Paradise they purchased an open field of 160 acres owned by Henry Miller, as well as strips of "right-of-way" toward both Chico and Magalia. In time, Miller's land was to become the town center of Paradise.

The town of Magalia already existed and thrived as a mining center. The residents were thrilled when they realized that they were to have a railroad. Its possibilities were at once realized by the mining, power, and freighting industries. Magalia would be the most important center of commerce on the Butte County Railroad. Ironically, Magalia was never to grow larger as a town, and the new Paradise was to become the center of population on the ridge.

Rumors that the new railroad was planned to extend across the Sierra and become another Southern Pacific transcontinental line proved false. When the Diamond Match Company had harvested the timber on the upper ridge, the tracks were pulled up (1975) and the railway was no more.

The major finishing of lumber for retail outlets was done in the nearby Barber plant, named for the president of the company. Barber's huge central building and several others that housed offices, as well as a subsidiary business providing service for the apian trade, were built on the site of a former trotting horses race track. Many local men and women found employment making and packing matches, giving a boost to the economy in general.

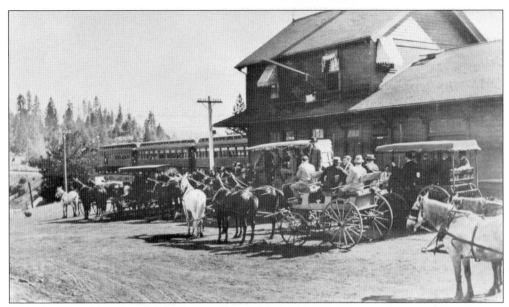

This photograph captures the first passenger train in Magalia to arrive on the Butte County Railroad, on October 8, 1903. Annie Warren recorded that it was a day of great joy. The local residents turned out in great numbers to witness the spectacle, taking care to keep the station between their nervous horses and the noisy steam engine.

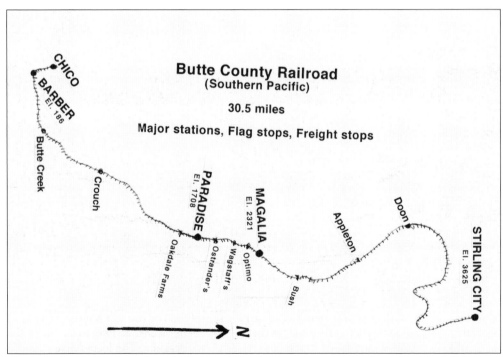

This map shows the Butte County Railroad's major stations and stops from 1902 to 1976.

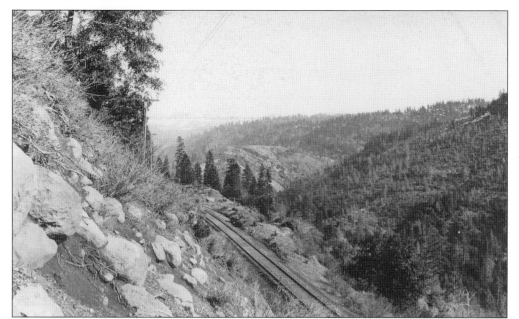

In this view, Sawmill Peak is directly to the right of the Butte County Railroad tracks, with the deep canyon of the west branch of the Feather River between the tracks and the mountain. Just around the bend of the track stands the Magalia Depot on the left. The photographer, who watched the laying of track and recorded many Dogtown-Magalia scenes from 1909 to 1912, was Emery Satterlee, the freight agent for the railroad and also the bookkeeper for Levi Cohn's store.

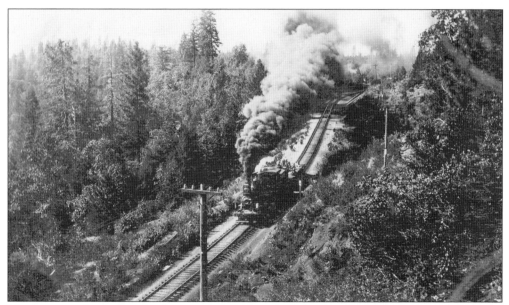

Never weary of snapping the shutter at a train nearing Magalia, Emory Satterlee took this view of an engine and work crew from the bluff that rises sharply to the town of Magalia. Today, in 2005, this railroad bed serves as the base for the Skyway, reengineered in 1983 to eliminate the steep hills that made winter travel hazardous through "old" Magalia. The locomotive steam in the chilly winter air, as well as the distance, blurred Satterlee's exposure.

Today hundreds of people commute south daily by automobile on the Skyway, which in 1983 claimed the space left after the Southern Pacific Railroad tracks were ripped out. The lady who risked life and limb by posing on the tracks is Bertha Satterlee, wife of the photographer who never tired of making images of the iron monster's trail—or of his new bride.

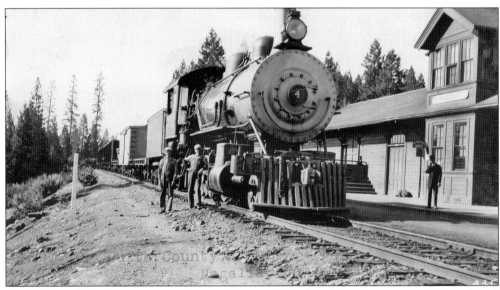

A northbound freight train is seen here pulling into Magalia. After the coming of the railroad, heavy mining or power plant equipment could be delivered much closer to its destination. Oxen and mule teams delivered freight from the depot to the customer.

Taken a short distance north of the Magalia station in 1903, this picture captures Sawmill Peak and the west branch canyon. It emphasizes the contrast between the dirt surface of the old Neal wagon road and the shiny new rails on the right.

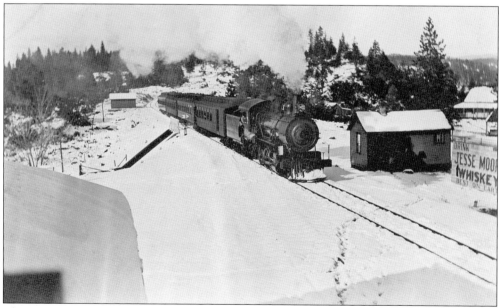

This passenger train has just come in from the north. The passenger service between Chico and Stirling City was just once-a-day service—up in the morning and back to Chico in the afternoon. It never ceased to be a matter for complaint for the ridge dwellers. To keep a doctor or dentist appointment, it meant a stay over in a Chico hotel at least one, sometimes two, nights. Left of center in this photograph, the dark line is the underpass for Neal Road (today's Coutolenc Road).

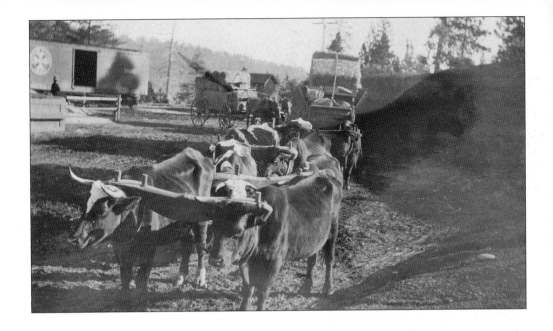

Above, hay freighted in a box car is being delivered from the Magalia station. In all probability it had been ordered by Cohn's store. The fact that four span of mules were required to pull a load of the size shown in the image below suggests that the load was of heavy equipment for the DeSabla Powerhouse in Butte Creek Canyon. The team was heading up into the wide center of Magalia to turn around.

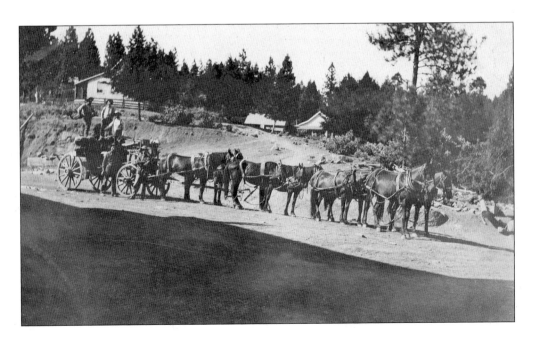

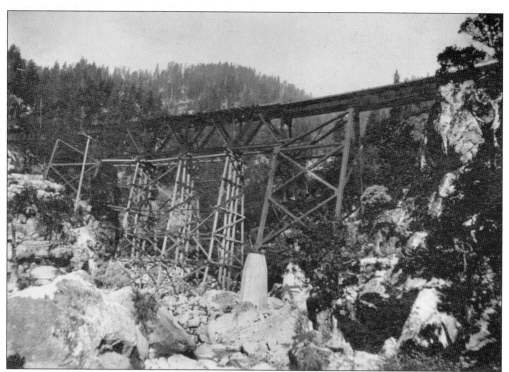

The terrain from Doon into Stirling City was difficult, with trestles over Little West Branch Creek and Long's Ravine. The trestle at Doon was walked by intrepid campers from the campground below. Some people fished from the trestle. The Butte County Railroad track maintenance crew at Doon seemed a cheerful group, except for the foreman (left). The handcar was manually powered.

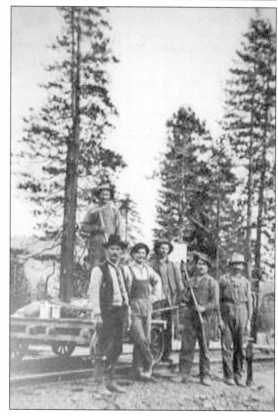

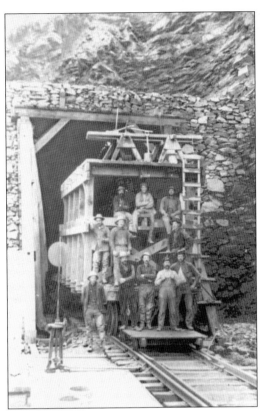

The difficult geography of the Doon ravine required use of a tunnel, 720 feet long. A crew worked regularly inside the tunnel to shore up falling rock. In 1949, a general cave-in of the tunnel required that it be abandoned and new track laid over a longer route.

The Stirling City depot was identical to the one in Magalia, both being built to Southern Pacific specifications. It was situated on the southern end of Stirling, from which point the Diamond Match Company Railroad ran its own tracks. The size of the crowd suggests that this was the first locomotive to reach town. In 1939, this station burned to the ground.

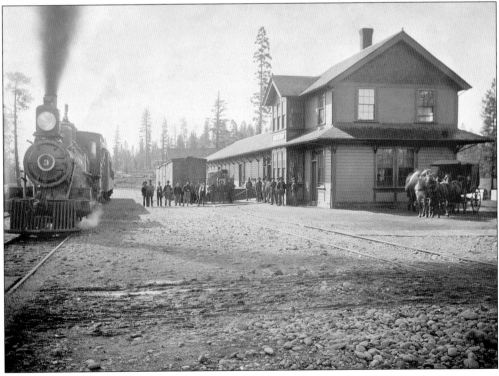

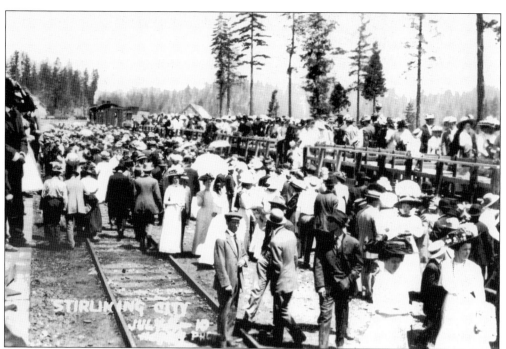

On July 4, 1910, the Butte County Railroad ran an excursion trip to Stirling City. Apparently hundreds arrived in town for the speeches and picnics that were typical Fourth entertainment.

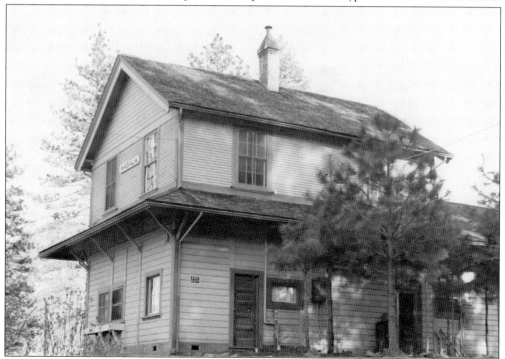

The Magalia station appears here in 1988, after closure. The building is very solid, characteristic of Southern Pacific (SP) depots. It has since been remodeled as a restaurant and, through several managements, continues to serve meals in 2005.

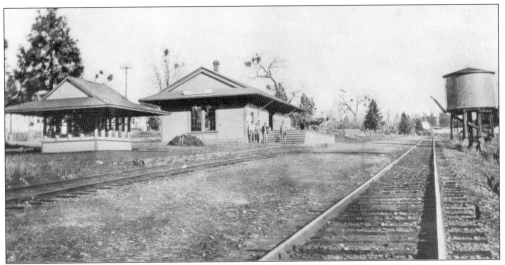

This is the Paradise Railway Station as it appeared in 1912. This smaller model of an SP plan has not withstood the elements as well as the Magalia station has. It has been acquired by the Town of Paradise to be restored within a city park as a railway museum in the near future.

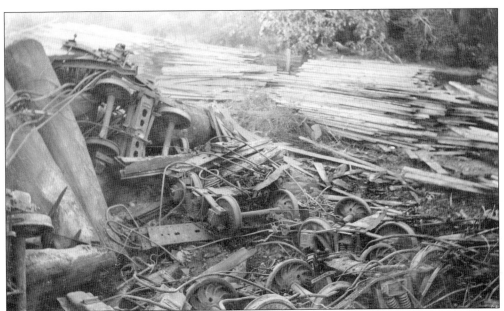

Although accidents on the Diamond Match rail lines were fairly common, only one derailment that resulted in death of the engineer and the brakeman occurred on the Butte County line. In 1909, a heavily loaded train of 30 cars had difficulty slowing down through the town of Paradise five miles below Magalia, dumping lumber and tearing up flat cars and track on the sharp curve below the town.

Three

MAGALIA'S DAM, PARADISE'S WATER!

The history of water rights and the battles to establish claim to this invaluable element needed for human existence are almost synonymous with the history of California, so wrote historian W. H. Hutchinson, in his analysis of our state.

As the Magalia mining industry waned and the ambitious would-be orchardists of Paradise just to the south were frustrated year after year by the dry summers typical of the climate, a handful of astute Paradisians demanded that the community act in unity to solve the problem. At an election in 1916, the 400 residents of a hastily drawn up geographical area (Paradise was not incorporated), agreed to issue $325,000 in bonds as the Paradise Irrigation District. The bonds would be paid back by a tax imposed on all property owners.

The water rights to Little Butte Creek were acquired from the Pacific Gas and Electric Company (PG&E) whose DeSabla Powerhouse had obtained alternate sources of water from the west branch of the Feather River and, later, Butte Creek. Magalia was at an altitude higher than the proposed reservoir, thus was bypassed by the ditch (and later by the pipe) that went to the first fore bay along Neal Road where it was fed into several branches of pipes to supply all of Paradise.

Though not to be helped with its own need for water for domestic use, the Magalia community watched the dam being built, as it were, on their doorstep. The dam called for the flooding of the little valley where E. B. Kinson and John B. Rorabough had lived on small acreages along Little Butte Creek. The Nimshew-DeSabla Road followed the stream and crossed it midway up the valley. The road was rerouted along the western wall of the reservoir. Today that curving, narrow 1.3-mile segment of the 1917 highway is called the Dogtown Road and maintained by the county for public use.

The method used to build the Magalia Dam was called puddle fill. Interestingly it made use of techniques popularized by mining (hydraulic earthmoving) and by logging (the donkey steam engine as a source of steam power to move sluicing timbers). The water came from Little Butte Creek above the dam. (The Paradise Irrigation District (PID) has a file of some 150 early photographs of the building of the Magalia Dam. Most of the images in this chapter are from the PID files.)

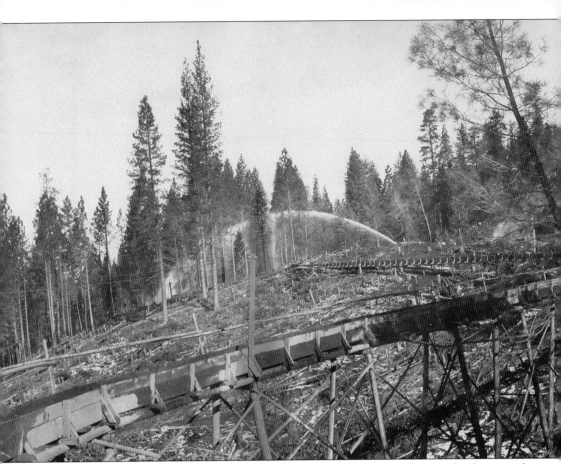

A stream of water pumped against the wall of the canyon just west of where the dam is to be starts to send a mixture of water, mud, and gravel through the first sluices.

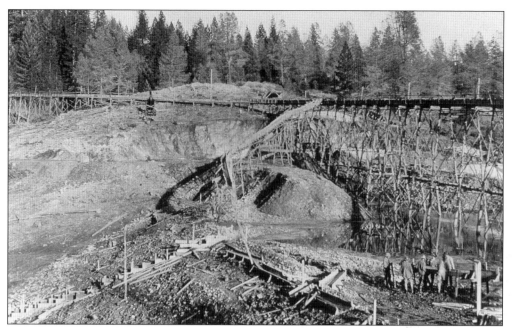

The dam was constructed between the two walls of the wide canyon of Little Butte Creek. Between the walls, a natural hill served as a base from which to work and provided the foundation for one side of the spillway eventually to be constructed on the left. A tunnel has been drilled through the hill (center, just above the sluice) through which to run the outlet pipe. The sluice is directing material into the upstream foot of the dam. Note the donkey engine on the hillside.

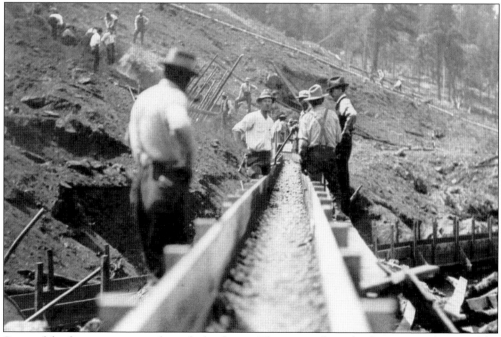

Some of the first water comes through the sluices. There is no sluice for the water to the top of the slope as it poured down the hillside in a self-carved channel. That would be filled in later as the dam rose. In the rear is the pipe that carried water from the pump up the hillside to the monitor.

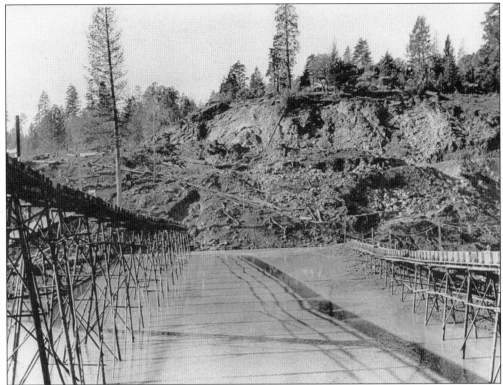

Water covered the dirt fill and drained away naturally. Many years later, when the safety of the dam (in case of an earthquake) was questioned, this saturation of water was pointed to as a weakness in the basic structure. The camera faced the west wall, from which most of the fill came.

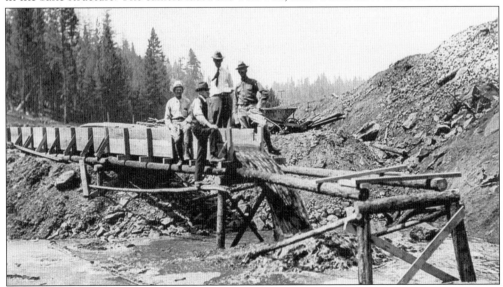

During the earliest stages of the dam construction, the engineer and three foremen met as water-laden fill came through the lower flume. They were Ivan Goodner, engineer; Mr. Alberts; Mr. Kraner; and Mr. Reiffer. For a period, the Magalia Reservoir was called Lake Goodner, but this name did not catch on. None of the men stayed in the community after the dam was finished.

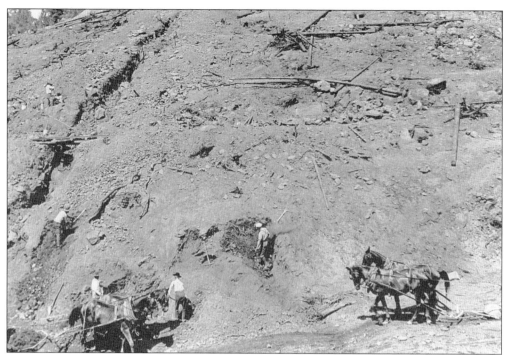

The supports for the sluices and flumes were added as the dam grew in height. Here men with horse-drawn Fresno scrapers are digging holes to support the poles of the framework of the sluices.

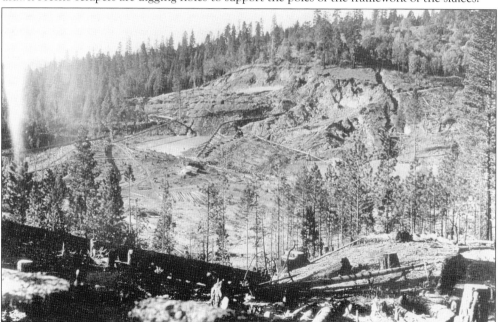

Taken from the top of the east wall of the canyon, this scene captures the chuffing donkey engine's smoke on the left and the monitor playing against the west canyon wall. The fill is being directed into the space between the west wall and the natural hill inside the structure of the dam. Today's Dogtown Road runs along the side of the west wall, probably at about the level of the monitor. Some signs left on the earth by the removal of topsoil are visible still.

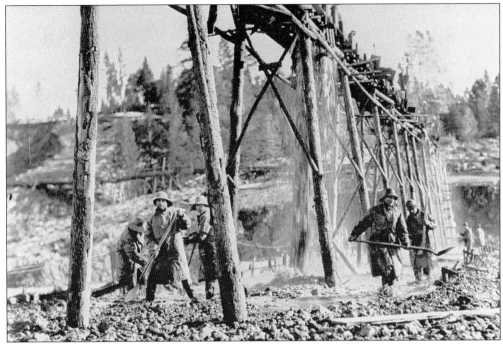

The work distributing the dam's fill was wet and nasty. The water was not particularly cold, however, and Magalia summer days are warm.

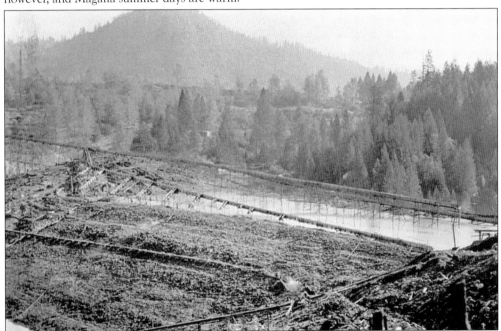

The welcome sight of Sawmill Peak in this shot orients us to the landscape of today. A glimpse of the Magalia Railroad station is possible. The filter plant of today is where the stand of trees is most luxuriant in the picture. The height of the dam has not changed much from that of the 1917 dam, but it was widened considerably and more fill added in 1975 when the Skyway was rerouted over the top of the dam.

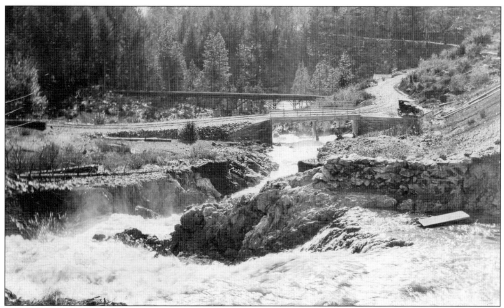

This picture was taken from the top of the dam on the east side of the spillway about 1918, or at the first time the dam was filled to overflowing. The road that passenger vehicles followed runs along the berm of the dam where the automobile is parked. The bridge is still in use by the Paradise Irrigation District, but the road that doubled back around a rocky hill before turning to become what is now the Dogtown Road has virtually disappeared. A small segment of it is still visible south of the dam on the west side.

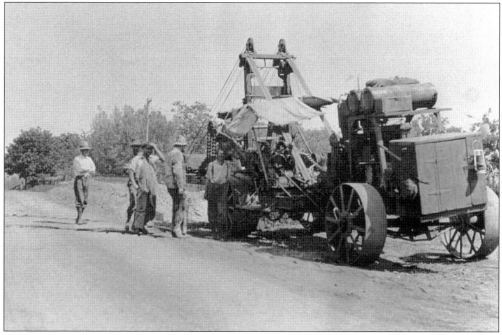

The trencher that was purchased to lay the pipe distribution system throughout Paradise had a hard time of it with the huge rocks that early residents had to cope with. A hand-digging crew was kept busy, as well as the crew that operated and repaired the trencher.

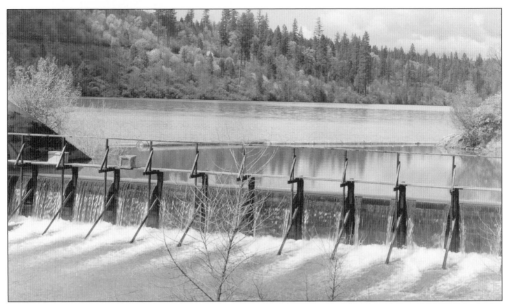

Although the population of Paradise was less than 2,000 in 1930, before that date the Magalia reservoir had run dry twice during the summer. Both drought and careless use of irrigation water were factors in this dire situation. Until an extra reservoir upstream was added by the PID in 1955, flashboards across the spillway were added to raise the level of the lower reservoir. In 1980, the flashboards were used for the last time.

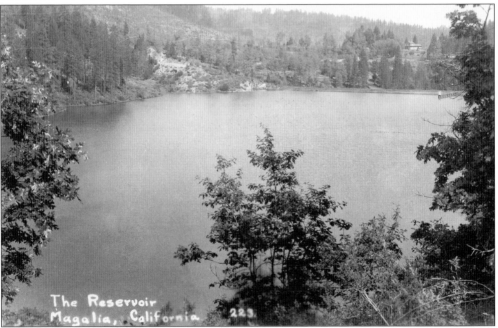

When filled, the Magalia Reservoir is a beautiful dogwood-decorated scene. When first filled, swimming was allowed in the lake, but as Paradise residents used the irrigation water more and more for domestic use, swimming was forbidden. It is also a recreation area for small waterfowl. The serpentine hill, where only the rare McNabb cypress grows, is clearly visible on the southeast shore of the reservoir. The Magalia Railway Station still forms a focal point.

Four

MINING IN THE MAGALIA DISTRICT

The first mining done by the forty-niners was by pan, rocker, and sluice. The object was to find and separate the loose dust and nuggets that were hidden in stream beds.

Very soon, more sophisticated ways were invented to release gold from gravel—or from hard rock—each requiring a different method. As luck would have it, the methods that were most successful turned out to be the most destructive to streams, fish life, and farmland. Farmers, sportsmen, and steamboat companies became lobbyists, pitting themselves against the mining corporations and eventually winning out with laws passed to prohibit mining pollution. In 2005, we still find weekend hobby miners around Magalia employing much the same primitive techniques of the forty-niners.

There have been literally hundreds of mines and prospect holes in the Magalia area. In hills and streams once sparsely populated, it was common to walk off and leave those holes and mine shafts, from which today an occasional family pet or adventurous youth must be rescued.

A mine needed water in large quantities for producing steam and, later, electric power, and for washing the gold free from gravel and dirt. Some of these ditches that carried water to a mine survived to be incorporated into the system of the Pacific Gas and Electric Company. The 1870s Hendricks Ditch now carries water from the west branch of the Feather River to the DeSabla Powerhouse on Butte Creek. Other ditches were adapted for crop irrigation purposes. The Steifer ditch (pictured here) along the west branch carried water to a private powerhouse producing electricity for the Steifer Mine.

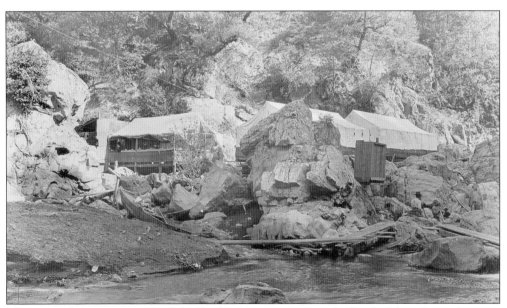

This view of the west branch of the Feather canyon camp at the Steifer Mine shows the tents of workmen whose job it was to see that electric power from deep in the West Branch Canyon reached the mine on Steifer Road. Once in camp, workmen rarely left, except on rare days off. The climb up to the Neal Road was very strenuous.

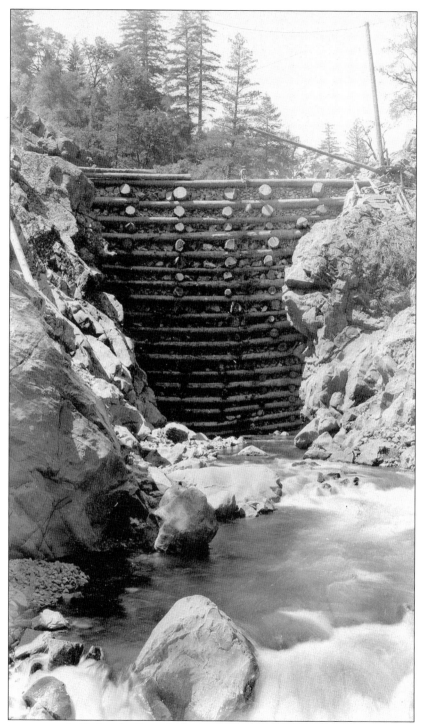

Water was impounded behind a Lincoln-log dam on the west branch of the Feather River to supply the Steifer powerhouse with water falling fast enough to turn the turbine. Logs to build the dam were thrown down the side of the canyon. The breaking of the Philbrook power dam in 1909 caused the washout of this log dam and elaborate power manufacturing setup.

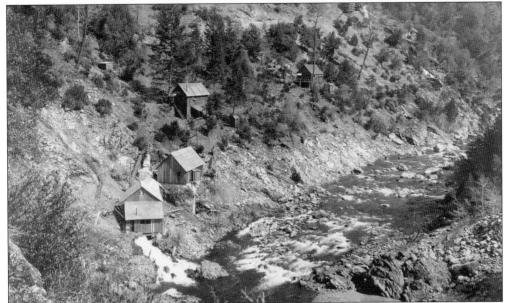

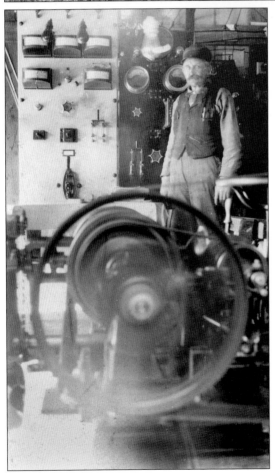

The Steifer water ditch runs across the top of the picture. The water was fed by buried pipe into the powerhouse and returned to the river. The mine itself was several hundred feet higher, above the rich buried Magalia Channel. The Steifer Mine shaft was along the road (misspelled Steiffer) where a carefully monitored community existed. The mine owners kept tight discipline, enforcing showering and a change of clothing when entering or leaving the mine. They forbade men to leave camp, except on rare occasions. They hoped to prevent the theft of gold by the workmen and brought elaborate diversions into the camp.

Compared to today's complicated power plants, the interior of the Steifer plant appears remarkably simple. One supposes that a careless operator could have electrocuted himself easily enough.

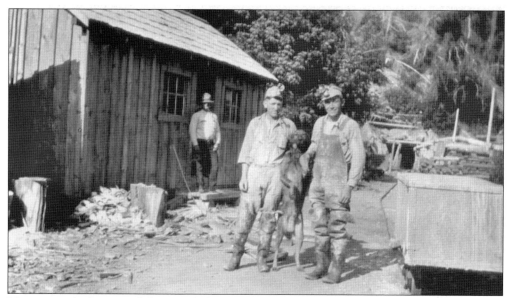

Many mine shafts entered the mine below and ran horizontal to the surface, only to turn sharply downwards or off to one side or the other. Mines often resembled mazes and were dangerous to enter at any time by a stranger. There was much more danger if the mine had been abandoned, as cave-ins could be expected. Remember, there was no light except that carried by the individual. The entrance to the Dix Mine (on the west canyon of Butte Creek) is nearly hidden. Notice the carbide lamps on the miners' caps.

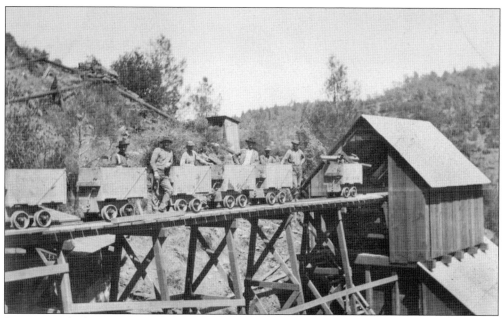

Some mine shafts were intended to go straight down toward the suspected gold deposit. Lifts were built and powered by steam (and later electricity) to bring the "pay-dirt" out, as in these Cape Horn Mine ore cars. They were emptied and lowered with the workmen back into the gloomy depths. The upper opening on the shaft of the mine was high above the source of the pay gravel on the west canyon wall of the west branch of the Feather River.

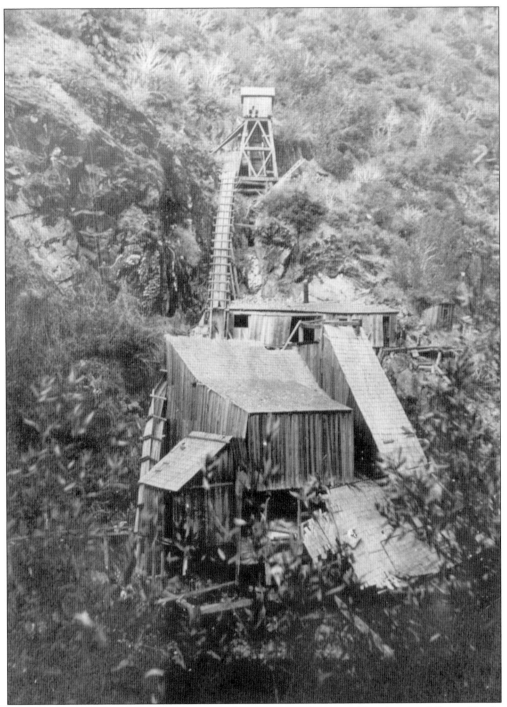

The Dally Mine was on the Middle Butte Creek canyon, between Nimshew and Butte Creek. The underground gold source sought was the rich Magalia Channel. Visible in this photograph is the shaft, where gold came out in carts and was sent down an ore chute to the mill below for processing.

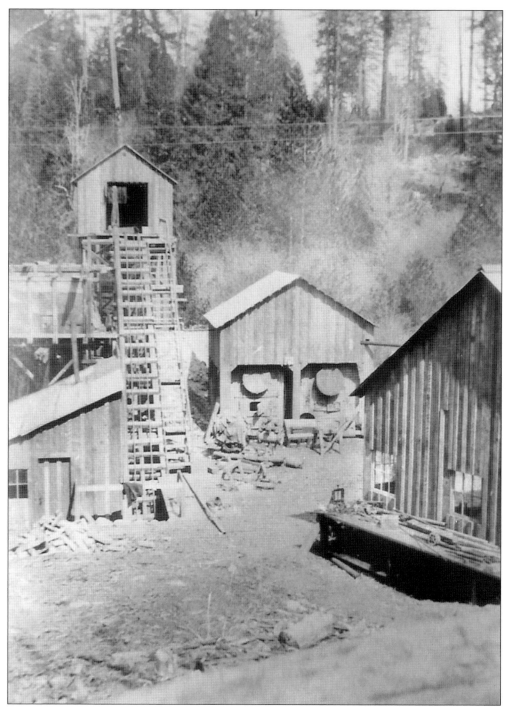

The Princess Mine had earlier been known as the Aurora, then later the Cory. It was located on the west side of Little Butte Creek and aimed at taking gold from the Magalia underground channel. It was the first mine from which the modern Del Oro Water Company pumped when the bright idea of using water from flooded mines for domestic purposes came to Sam Fortino, an upper ridge developer of the 1950s.

Another mine on the west branch of the Feather River at Whiskey Flat, downriver from the Steifer camp, was the Genii. Its owner was Almon "Highpockets" Smith, a Magalia resident with an international reputation. Mining buildings were seldom built for beauty, only for utility.

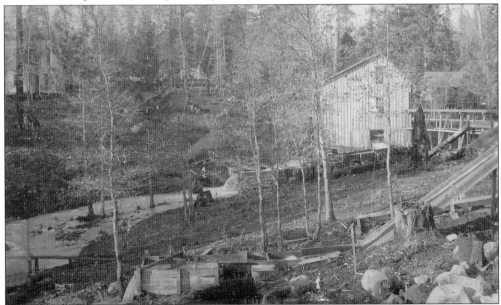

The richest (and wettest) of the mines to tap the Magalia Channel was the Perschbaker, later renamed the Magalia. This mine is near the center of the Sierra Del Oro subdivision above Magalia off Brandy Lane. The mine is now pumped to provide water for the both that subdivision and Paradise Pines. The channel ravine of the water disposal system for the Magalia Mine can still be clearly identified today. The air compressor house is in foreground. At far left is the superintendent's (Gassaway) house.

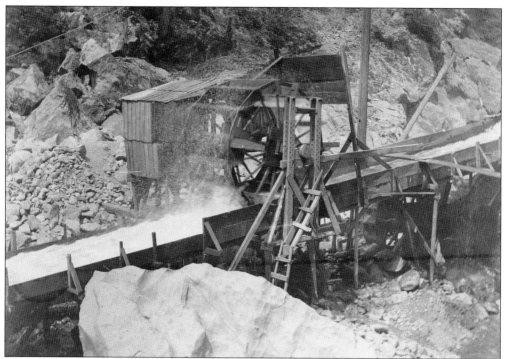

Mining engineers were very resourceful in finding sources of power. In the Bon Ami Mine on Butte Creek, water diverted from the creek and falling in a ditch drove the water wheel that powered the derrick that raised the ore cars from their shaft a short distance away. The same ditch provided water for the sluice boxes and dropped creek trout into a sack downstream from the wheel.

Although some mining operations dated back to the 1850s, others were starting after the turn of the 20th century. This Sunday visit to the camp of the Mammoth Mine on Middle Butte Creek was made by friends from San Francisco. Notice the two spare inner tubes. Camp tents are on the right.

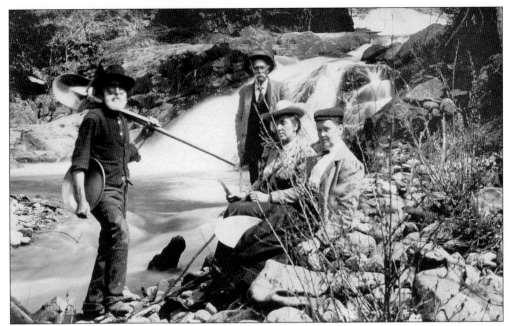

This image is of a Sunday panner, the neat bearded gentleman with shovel and pan. He is identified as Mr. Uhrey of Paradise, visited by Lawrence and Iva Charlton who have come to see him try his luck at panning out some gold dust. The stream is probably Little Butte Creek. Watch out for that poison oak.

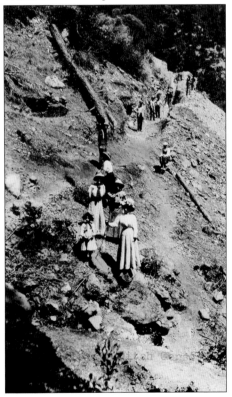

A walk on a Sunday afternoon takes a group of friends down into the canyon to visit a mining camp. It looks easy, but wait for the long pull out! It would have been prudent to borrow a burro.

Five

GHOST TOWNS AND MEMORIES

NIMSHEW

Located along the eastern edge of Butte Creek Canyon, Nimshew's earliest history has been almost destroyed. The sadly looted burial sites with beads, tools, and stone mortars left by the Maidu tribes that camped here for the summer cool and fall hunting have now disappeared—protected too late. The name of the mining town that formed in that area is based on the native word for "little water," Nim-su-en. The Nimshew Creek, as contrasted with the much larger Butte Creek (Chulamhew) and Big Kimshew Creek further up the ridge, carried but a small part of the water needed for today's population of retirees who live on small acreages along the heavy wooded, wildlife-rich Nimshew Road. There were no mines in Nimshew, but they were hidden in canyons around the area, the Coal and Emma being among the first. It is in these mines and others that at least two generations of the families settled to eke out a living. A voting precinct was established in 1861—evidence of an early residence at Nimshew. Rugh is the name most often given as the earliest settler. Saul Rugh and his wife, Rebecca, came in 1860, having mined earlier at Forks of Butte and Inskip. They were not the first, but finding a good spring along a ravine draining to Butte Creek, they homesteaded. The Rughs gave land along a point on the Butte Creek Canyon for the cemetery, and there are numerous Rughs buried there, including many children. It is still an active cemetery, with an average of two burials a year as the few remaining members of old families die. In 1865, Henry Evers was the first to marry in Nimshew in a house he built there. The Evers family, too, is well represented in the cemetery, with an occasional burial like the Rugh family. Evers's descendants still live in Butte County. Other early settlers include the McClellans, Nesbits, Atkins, Slimmers, and Sewards. Children from the large families provided pupils for the Nimshew School over a period of more than 65 years.

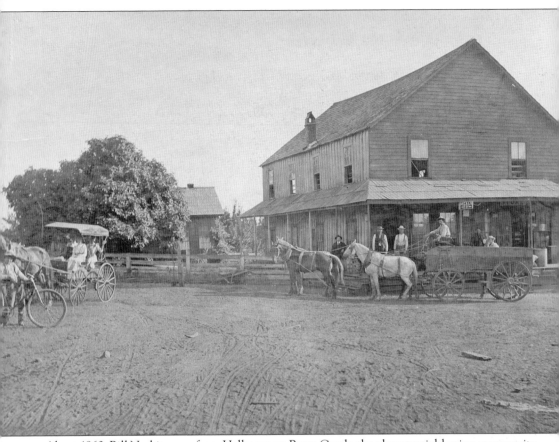

About 1860, Bill Nesbit came from Helltown on Butte Creek, the closest neighboring community, which is now completely swallowed by time. His partner was a man named Chandler. They built a store where the Centerville Road (then called the Helltown Trail) and the Nimshew Road met at right angles to supply miners. In 1893, the Walkers bought the business and put up a new building that stood at the junction until 1923, when federal postal service was no longer provided to the Nimshew Post Office, which was housed in the store. The store closed soon after, and Linda Seward, long faithful to her post, left to be married to the sweetheart all Nimshew knew about. They wished her well.

In the early 1860s, Sam McClellan Jr., a forty-niner, built Nimshew's first hotel. It stood on the east side of Nimshew Road, today a vacant site marked by the old trees that grew around three hotels, each burning in turn. McClellan applied for a post office in 1880 and became the first postmaster. When McClellan was elected Butte County assessor and moved to Oroville, the Terhunes and their three daughters took over the hotel.

The Rugh house stood on the side of a small ravine along today's Cemetery Road, where a rare spring gave them water. Most of the early settlers hauled water or got rights to the water ditch belonging to the Valley Light and Power Company. This is the second of the Rugh homes, the first having burned.

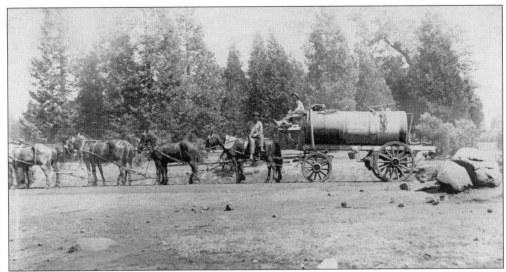

One of Nimshew's proudest moments came in 1907 with the oiling of the dirt road. The tank and crew came from Paradise. Leon Van Ness is the driver of the four-span team. Al Strong poses on a pony's back.

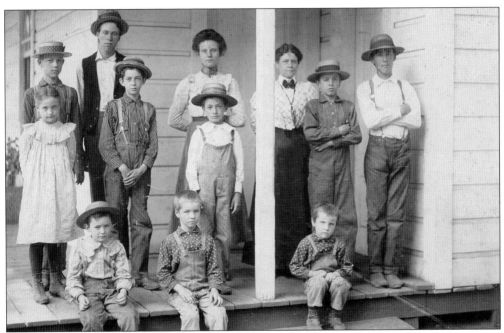

The Nimshew School was moved from time to time to accommodate the jobs of the wage earners. This 1899 student body picture was taken after the school house was moved during the middle of one night to be nearer to the Magalia Mine. Pictured here are (first row) Edwin Understock, Judson Matheson, and Lawrence Matheson; (second row) Gladys Bishop, Donald Matheson, Leonard Richardson, Ralph Hupp, and William Rorabough; (third row) Earle Preston, Frank Rorabough, Rose Bishop, and Miss Baker.

Old-timers mined just because they enjoyed the search. As late as the 1960s, these partners, Nat Lambert, Edgar Rugh, and Aubrey Rugh, sat down to divide the small box of gold dust they had salvaged from a mine shaft.

Many surviving images of the area's once bustling, now deserted communities were taken by itinerant photographers in the 1860s and 1870s. These tradesmen with tents and tripod cameras traveled to mines, ranches, and towns in search of paying customers. They recorded for profit what is priceless today.

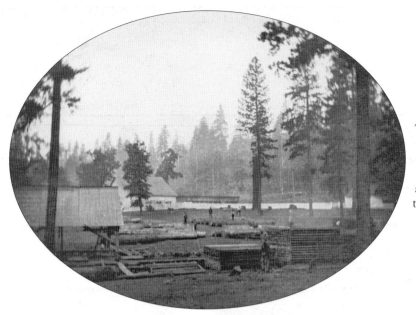

This late-1860s photograph shows the Hupp sawmill, left, and the barn in the distance.

HUPP

Before 1849, John Hupp came to California from Virginia. Hupp acquired land from Manoah Pence, and brought a brother Uriah and two sisters. He involved himself in gold mining after the 1848 discovery, but his lasting vocation was that of producing lumber for the many needs of a bustling California. He had milling equipment shipped around the Horn. After trying out a site on Mosquito Creek (off Little Butte Creek) he bought land on Humbug Road in 1859, operating a lumber business there until his death in 1898. He married Roseanna Wooliver in 1865; they had six children. Hupp's Mill supplied the lumber from which the first houses in Chico were built. His oxen teams and wooden wheeled wagons delivered unplaned lumber all over the county, including Magalia, Paradise, Oroville, and Cherokee, for homes, barns, and mining shaft timbers. Hupp was also a miner, developing several claims, drift, hard rock, and hydraulic. His best known mine was the Red Gravel on Butte Creek near Centerville. To operate it he ran water in ditches from Clear Creek, Kanaka Creek, and Middle Butte Creek. He was a man of high enthusiasm, quoted in the *Northern Enterprise* in 1873 saying, "Do not care a damn whether the claim pays or not; it is fun to watch the huge boulders leap from their beds and go rolling, tumbling, crashing down into the ravine below." Laws enacted by the California legislature put an end to his pleasure. Hupp owned much of the land in and around Dogtown, and built several buildings including a hotel. In 1860, he gave cemetery land as gift to the town. Hupp's Mill became a community unto itself. The complex included a boardinghouse for the workmen, a bar, a store from which all manner of supplies were sold, and for nearly three years, 1909–1911, a post office. Gardens and orchards produced much of the food, and dairy cows provided the milk and cream. Mrs. Hupp had her own section of the house to which she could retire with her children from the noisy crowd of workmen. Although it ceased to produce lumber well before the 1961 death of John's son George Grover Hupp, the property was still owned by Ralph Hupp, the youngest son, in 1976 when it was honored as a business of 100 years with the same California pioneer family. Today the acreage is the property of the Pacific Gas and Electric Company. Bright flames of the leaves on old poplar trees highlight the spot in the fall, as do the few old apple trees that still produce fruit. Few other signs remain.

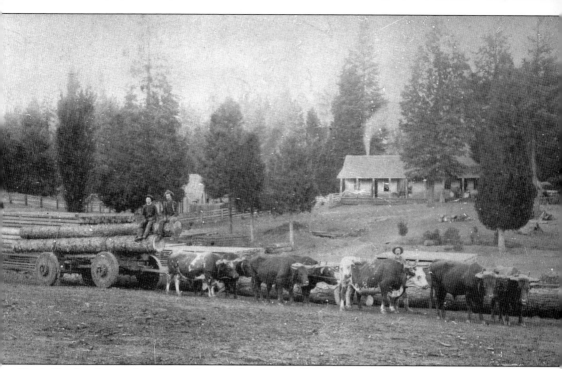

Copied by family members from a framed photograph, this scene is of the Hupp home with John Hupp's prized team of oxen in the foreground. The oxen cost Hupp $250 a span-an extremely high price to pay for oxen at the time. They were brought in from Oregon from a tested blood line showing great strength and endurance.

The Hupp place had many buildings, from cider house to wood house. This was the saloon provided for the use of employees and visitors. Many of the latter were rented lodging in the Hupp boardinghouse.

This formally posed shot, c. 1888, included some of the longtime workmen of the Hupp Mill. Pictured here, from left to right, are (first row) unidentified; Ed Martin, Hupp's bar tender; Jim Wheelock (later tried for murder of Ed Martin's mother and sentenced to hanging on very questionable evidence by a jury inflamed by public outrage according to Ralph Hupp); John Hupp, at that time about 59 years old; (second row) John C. Hupp, eldest son of John Sr. who died at age 18 soon after the photograph was made; Ed Konkle; and George Melvin.

64

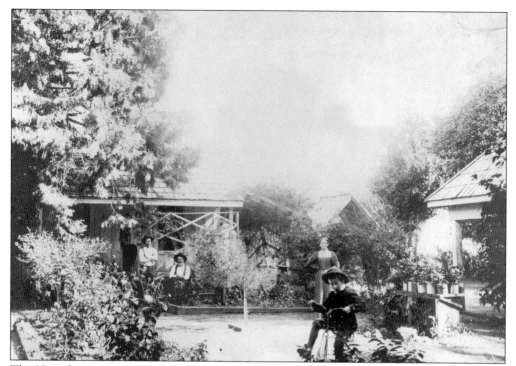

The Hupp home is pictured here about 1896 and, from left to right, are George Grover Hupp, the second son of John and Rosa, who continued the lumber mill for many years after John Sr.'s death; John Hupp; Rosa Hupp, John's wife; and on the tricycle, Ralph, youngest of the Hupp's six children.

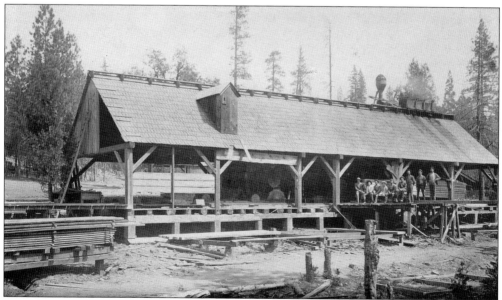

This is last of the Hupp mills, about 1903. Notice the spark control on the chimney of the steam engine used. Containers of water, in case of a fire, are on the roof to the right of the chimney. Through 65 years of milling, the Hupps never lost a mill to fire in spite of constant danger.

Coutolenc-Lovelock

Two ghost towns remain today at the sites of the 1855 settlement of Lovelock, which became Coutolenc, and the second Lovelock that took the name of the post office. George Lovelock, the town's first settler, found that keeping a store at the gold boomtown of Forks of Butte (now entirely gone) was lucrative, but he also was keenly aware of the isolation of that town and the near impossibility of getting a good road into the Butte Creek Canyon. While Lovelock lived in the town bearing his name, a post office was formed in 1871. He operated a small mill to harvest sugar pine, and retailed lumber along with other goods. When Lovelock left to resettle in Nevada, and he sold out to Victor Poumarat, a successful attempt was made to move the Lovelock Post Office to a new settlement forming at the junction of the Lovelock Road and what is now Skyway. In the scramble to make everyone happy, the post office on the lower road was renamed Coutolenc, as Eugene Coutolenc had, by 1890, purchased the site. It has been known as Coutolenc ever since. Today Coutolenc Road through "Old Lovelock" is paved, and the buildings seen here are gone. It is still a winding rural road, and the charm of the area is evidenced by an influx of residents who make the area a bedroom community for both retired persons and commuters to Paradise and Chico.

George Lovelock, first settler at Lovelock on the road pictured here, came to California with the gold rush.

No picture of the 1870 hotel erected by George Lovelock remains, but it was replaced by the Coutolenc Hotel by 1890 and existed well into the era of the automobile.

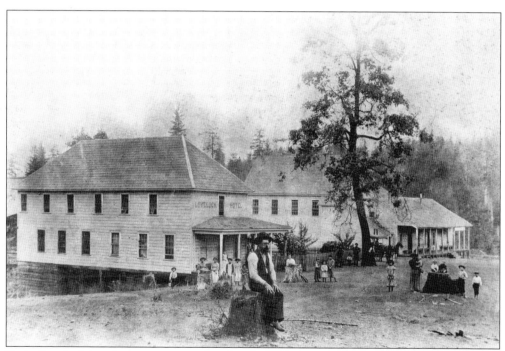

Today Lovelock is a ghost town except for a bar. In 1890, the town boasted both hotel and saloon. It was known as a haven from the summer heat of the Sacramento Valley, and its hotel well filled with visitors. Ike Kitchen, prosperous proprietor, poses center from a stump. The town also had a well-attended school.

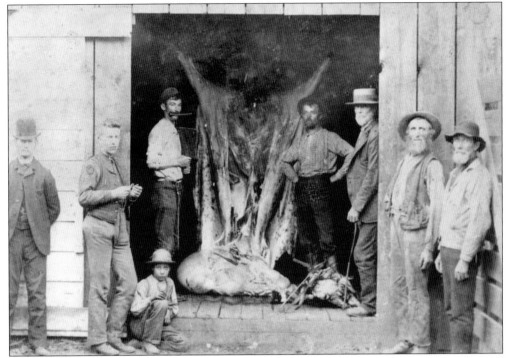

In the Lovelock slaughter house, Tom Church, Jim DeLong, and Grandpa Understock stand beside a carcass. On the left is Walter Stone, the Lovelock teacher, and two unidentified people. On the right are kibitzers F. O. Smith and Grandpa Kitchen.

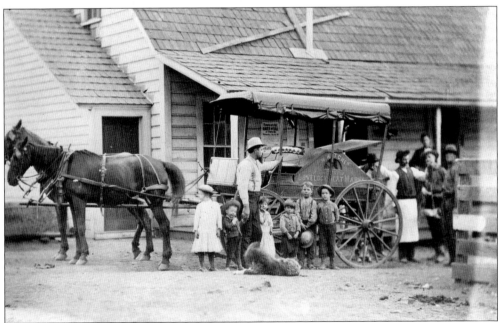

The "New Lovelock" thrived for many years. The slaughter house served meat to many communities, thanks to Ike Kitchen's meat delivery wagon, seen here in front of the Kitchen store.

Toadtown

Toadtown was an early mining community on Little Butte Creek along which miners prospected for gold during the gold rush. Originally called Allentown, it may have been renamed because of a family who had towheaded (white-blond hair) children. Called "Towtown" by miners, the name was corrupted into Toadtown. In 1859, George Lovelock built a sawmill on the creek. The Toadtown Mine was being worked as an underground, hard rock operation as early as 1865. Work apparently continued into the 1930s. The building that housed the ball mill was gone before 1970, and the rest of the facilities, excepting a 1930s building, burned in the mid-1990s. A 1910s or 1920s cabin stills sits across the creek. A number of relatively modern residences are in the Toadtown area today.

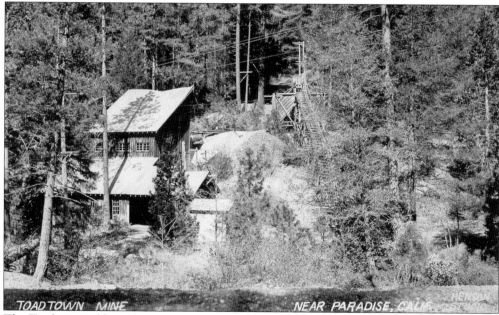

The Toadtown gold mine is seen above. On the left is the ball mill where the ore was crushed before extracting the gold. To the right, partially obscured by trees, the track slants up the hill on which ore cars were pulled out of the mine.

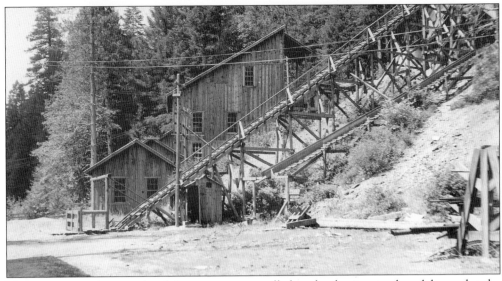

The mine was underground and the ore cars were pulled up the slanting track and dumped at the top. Gravity carried the ore down into the building with the slanted roof where it was crushed by a ball mill. The ground shook when the mill was running and the miners were afraid that the mine would collapse.

This building erroneously has been called the "Toadtown Hotel." Actually, the mine superintendent's living quarters were upstairs and ore processing rooms downstairs. This photograph was taken in the 1970s with Ray Velliquette and his eight-year-old daughter sitting on the porch.

POWELLTON

Powellton was originally called Powell's Ranch after Richard. P. Powell, who first settled here in 1853. In 1872, when the community got a post office, it became Powellton. Powell surveyed and constructed, what is called Powellton Road, up the ridge to Inskip. Powellton became the intersection of the road from Chico to the Oroville-Susanville Stage Road that later became part of the Humbug Road. In 1856, to service the travelers, Powell built a hotel. By 1861, a large sawmill was built and by the 1880s there were three mills. There also were rich diggins in Butte Canyon and surrounding areas, which contributed to the growth of quite a settlement. In 1927, Powellton "got a shot in the arm" when Diamond Match constructed a double incline rail line through Butte Canyon to reach 250 million feet of timber on the west side of the canyon. Millions of feet of logs and even full-sized logging engines were hauled through the 1,500-foot deep canyon. The size of Powellton grew by leaps and bounds as Diamond Match moved its rail-portable houses and logging camp buildings into the settlement. By 1936, though, it was in decline again as Diamond Match closed the incline. While the logging railroad between Stirling City and Butte Meadows and the old stage road still passed through Powellton, its reasons for existing were mostly gone. People left, and most of the permanent buildings remaining slowly disappeared. Today Powellton is a true ghost town.

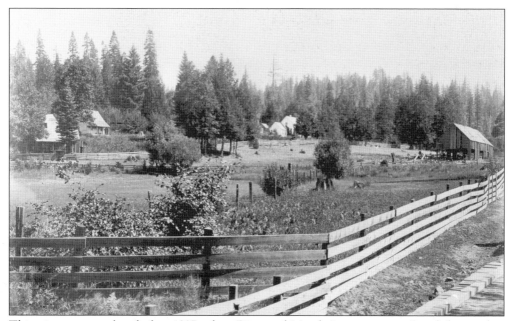

This picture was taken before 1927, when Diamond Match "came to town," and shows what early Powellton looked like. It was a rather rustic, rural community until Diamond Match came to town. Compare this photograph with the later image that shows all the Diamond Match portable houses.

This photograph of the "Old Thompson Place" was taken in 1968. In 1897, James Thompson owned a hotel in Powellton. He also had a five-man crew improving portions of the Powellton Road north of town to the Summit.

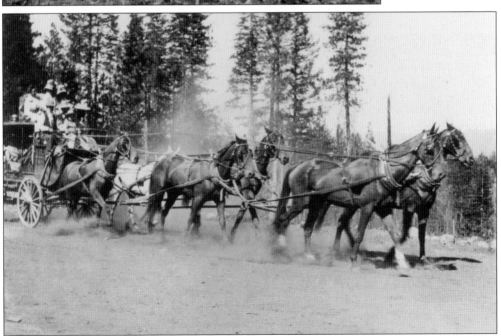

The Powellton stage moves along Powellton Road. A close look reveals that this mud wagon (a common type of stage) is carrying at least 15 passengers, nine inside and six on the roof and in the seat alongside the driver.

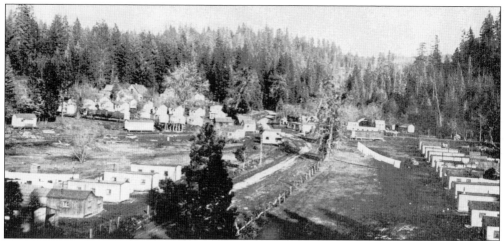

Diamond Match's portable houses dominate this view of Powellton taken in the late 1920s to early 1930s. Railcars are visible to the left in front of the houses on tracks that run across the picture. Slightly to the right behind the railcars is the white house that appears in the picture of early Powellton. In 1936, the portable houses were moved to Butte Meadows.

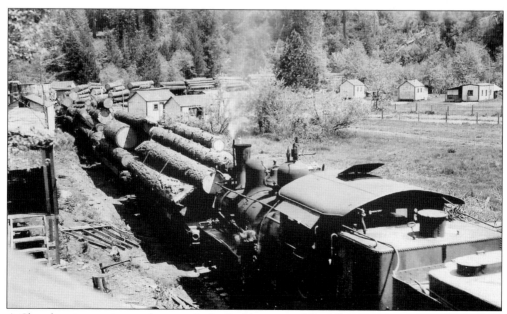

A Shay logging engine pushes a train load of logs out of Powellton on the way to the Stirling City mill. The date is probably before the mid-1930s as Diamond Match's portable houses are still in place.

INSKIP

Founded in 1857, Inskip was a gold mining camp up the ridge from Powellton and in later years Stirling City. It was on the Humbug Road or Susanville-Oroville Stage Road on the ridge between Butte Creek and the west branch of the Feather River. In its glory days between 1857 and 1864, it was "one of the liveliest towns in the county." There were 4 streets, a town square, nine hotels, seven saloons, 10 stores, two butcher shops, a bakery, five stables, three restaurants, a post office, plus homes and miner's cabins. All that remains is the Inskip Hotel. It originally was built in 1857–1858, burned in March 1868, and was rebuilt by that September. Called the Inskip Inn in later years, it was placed on the Register of National Historic Sites in 1975. It is frequented by a resident ghost that visitors, to this day, claim to have seen. In the mid-1900s, the inn was a ski resort of sorts, with a rope tow on an adjacent hill.

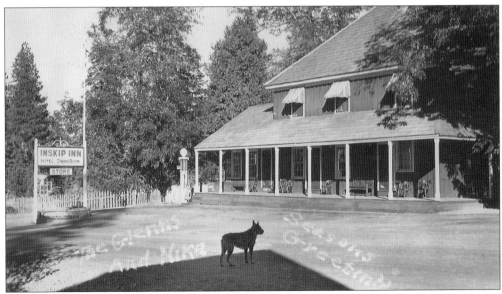

Judging by the vintage gasoline pump and the chairs on the porch, this photograph of the Inskip Inn was taken sometime in the 1930s to 1950s. Handwritten on the photograph is "The Glenns and Nika Seasons Greetings."

Chaparral House

Although it was never really a community, Chaparral House was a landmark in Butte County. It was built in 1857 as a hotel and way station on the Oroville-Susanville Road (also part of the Humbug Road in this area). Only a few miles up the ridge from the town of Inskip, it catered to stagecoach travelers and teamsters. Opening each year as soon as the road was cleared of snow, it closed when snow made it impassible. Alonzo Philbrook, for whom the Philbrook Valley is named, was the first manager of the hotel and stage stop. He and his wife, Eliza, ran it from 1860 to 1868, at the same time using it as headquarters for their cattle grazing. In the 1950s, the building burned to the ground. The two-story building was built in 1857 in Chaparral and the single story addition added later. In the 1950s, the structure burned to the ground.

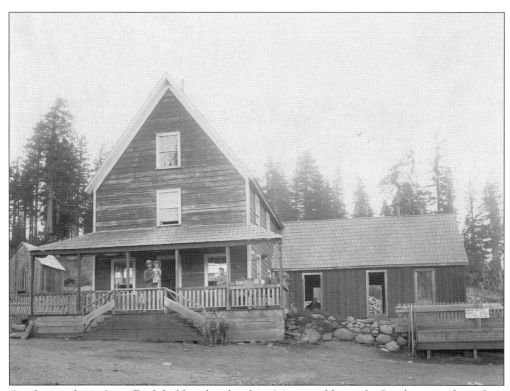

On the porch are Jerry Ford, holding his daughter Mary, and his wife. On the ground are their sons, Jerry Ford Jr. and Ray Ford. The small sign on the fence at the right is a billboard of sorts, advertising rooms and meals at the Union Hotel in Oroville for 25¢.

PHILBROOK

The Philbrook Valley likely first attracted white men during the gold rush. There are numerous mines in the mountains surrounding the valley, a few of which still produce gold. As early as 1857, Alonzo Philbrook may have grazed cattle in the valley. In 1877, cattleman Christopher Lynch drove a herd up the Humbug Road and established a summer camp in the valley. The wagon road ended at the west branch of the Feather River so everything was carried in by horses and mules, including Lynch's younger daughters who rode in meat sacks tied to a gentle horse. His wife rode horse back with a babe in arms. That year he built a wagon road from the river into the valley. He was followed by other cattlemen and a small community developed with a store and hotel, patronized by cattlemen, miners, and occasional travelers. In 1908, an earthen dam was built across the west end of the valley; it failed in early 1909. Seventeen years later, a new earth-fill dam was built for PG&E, the reservoir to supply water to hydroelectric powerhouses on Paradise Ridge. About 1936, PG&E started leasing lots around Philbrook Reservoir. Tents soon gave way to cabins, and reservoir has become a favorite spot for fishing and water sports.

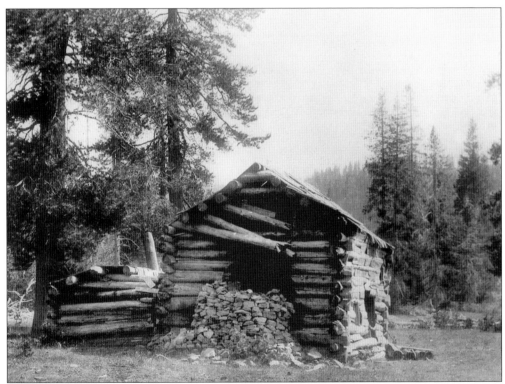

The remains of the Christopher Lynch cabin in the Philbrook Valley is seen above, c. 1906. It was located just above the site of the dams and was eventually stripped of any useable timber before the rising reservoir covered it.

Six

DIAMOND MATCH COMPANY

The sawmill/lumber business in the Sierra began long before the gold rush that actually started at John Sutter's sawmill in 1848. But it was the gold rush that put the business on the map. So much lumber was needed that forests, especially near mines and mining camps, were denuded of trees. Sawmills, large and small, sprang up over the Sierra, most disappearing when nearby timber was exhausted. A few, however, grew into companies with large timber holdings.

The Diamond Match Company operated in the eastern states until 1901 when it purchased over 69,000 acres of timber in Butte, Plumas, and Tehama counties. There were over 2 billion board feet of white and sugar pine in this tract. Most think that this timber was bought to produce match plank. Indeed the company made matches in Chico, but the real reason was to enter the lumber business that showed promise of considerable profits.

During 1902, land was cleared on the upper Magalia/Paradise Ridge, and by mid-1903 the sawmill was completed at Stirling City. In 1904, logging started down the ridge near Doon. Soon there were 2 million feet of logs in the mill pond. On September 1904, the first log was cut. The year 1905 saw the first full season, with 200 men working in the mill, another 200 logging, and 100 more extending the standard-gauge logging railroad. Started in 1903, the railroad had crossed the west branch of the Feather River to "Nigger Point," also called Transfer Point or Landing, south of Bald Mountain. Logging began on the mountain in 1904, the same year the company built what is likely the first fire lookout station in California on the mountain. In 1905, the first Shay geared locomotive, No. 101, arrived. The second, No. 102, arrived in 1906.

Logging on Bald Mountain continued until 1909, when tracks were built eastward into the Kimshew country. In this rough terrain, a meter- or narrow-gauge railroad was cheaper to build. Also Diamond Match had acquired meter-gauge railroad equipment, including six saddletanker engines, in 1907 along with the purchase of 93,000 acres of timber from the Sierra Lumber

Company. At Transfer Landing, logs were transferred from meter to standard-gauge flatcar for the trip to Stirling City. When Kimshew operations ceased in 1915, there were six logging camps, each with 100 men plus many of their families. Over 240 million feet of timber were sent to the sawmill from such camps as Ramsey Bar and North Valley.

In 1916 Diamond Match started logging west and north of Stirling City. Standard-gauge rails were laid toward Butte Meadows and such logging camps as Bull Creek and Bottle Creek were opened. Camp buildings were carried to the site on flatcars and then skidded into place using a steam donkey engine or a McGiffert loader, equipment used daily in logging operations. These were the same rail-mobile buildings used in the Kimshew camps. As the timber was depleted, the buildings were moved to a new camp and the rails removed to use again.

In 1925, the company closed these camps and pulled up the rails and logging operations begun at West Branch (of Butte Creek). Rather than build 45 miles of rail line to reach this timber, Diamond Match built a double incline in and out of 1,500-foot deep Butte Canyon. Everything needed at West Branch, including Shay engines and portable houses, were lowered down one side of the canyon by a huge winch and pulled up the other side by another winch. At least 250 million feet of timber on flatcars were moved to Stirling City through the incline.

In 1936, West Branch operations ceased and the incline was dismantled. Logs were now hauled from the Butte Meadows area over the old 1916–1925 rail line that had been rebuilt and extended. This continued until 1953, when Diamond Match closed the last of its logging railroads. Motor truck logging had started in 1939. It was cheaper to reach remote sites by truck than by rail. The Stirling City–Butte Meadows rail line became a logging road. In 1956, the Stirling City Mill was closed and burned while it was being dismantled. Sawmill operations moved to Red Bluff.

In 1964, the company, now Diamond National Corporation, built a stud mill on the sawmill site that operated for 10 years. When it closed, Diamond Match's Stirling City operation ceased forever. In 1992, Sierra Pacific Industries bought 232,248 acres of Diamond Lands and logging started again. But today, Stirling City is not involved except for the SPI district manager and several foresters working out of an office in town.

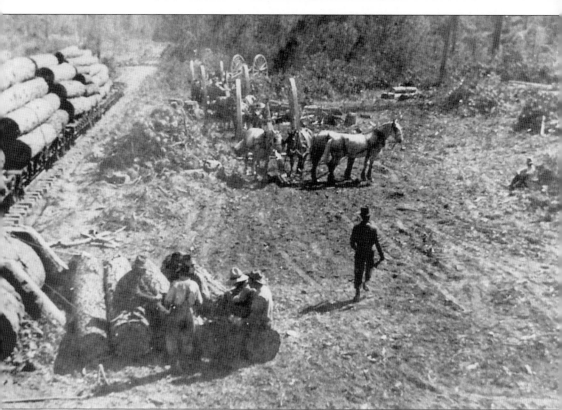

In 1904, Transfer Landing, south of Bald Mountain, was where logs cut on the mountain for Diamond Match's first logging operation were "yarded" (skidded to the landing). In the center rear are four Big Wheel log haulers, called "Katydids." On the left, men are sitting on logs that will be rolled onto flatcars and hauled to the mill.

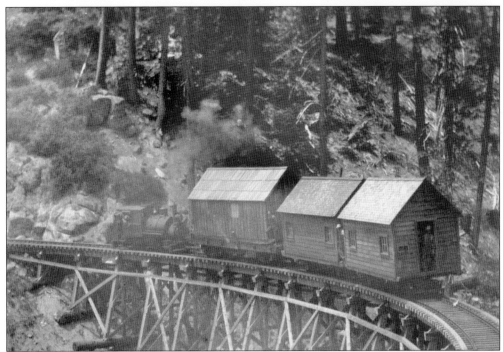

In 1915, a saddletanker engine pushes flatcars loaded with bunkhouses on skids to Kimshew Falls. In 1913, the entire camp was moved this way on the narrow-gauge rail line. Well into the 1930s, logging camp buildings were moved this way, by then on standard-gauge tracks.

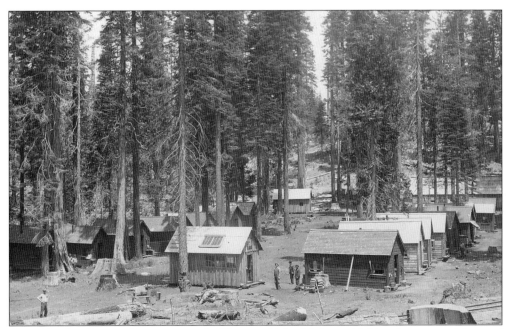

Camp No. 3 at Ramsey Bar was typical of Diamond Match's "portable" logging camps. Mounted on skids, the buildings were moved to the site by rail and then dragged into position by a steam donkey engine. The saw filer's house is the one with the skylight in the roof.

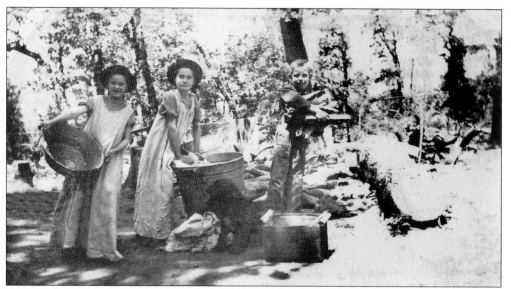

It must be wash day at Camp No. 3 at Cold Creek. Faye Orendorff carries water while her sister Bonnie scrubs cloths in a wash tub and Cloyd Pearce hauls firewood. Laundry was one of the chores shared by the children, but there was still time to play and go to school.

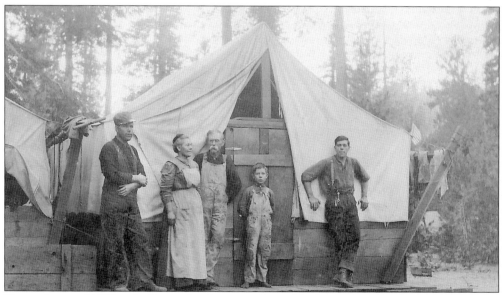

Pictured around 1909 is the Pearce family tent at Camp No. 3 at Ramsey Bar. Initially tents were used, but they were later replaced by rail-portable wood buildings. The Pearce family pictured, from left to right, are Jim, Mattie, Dave, Cloyd, and Tom.

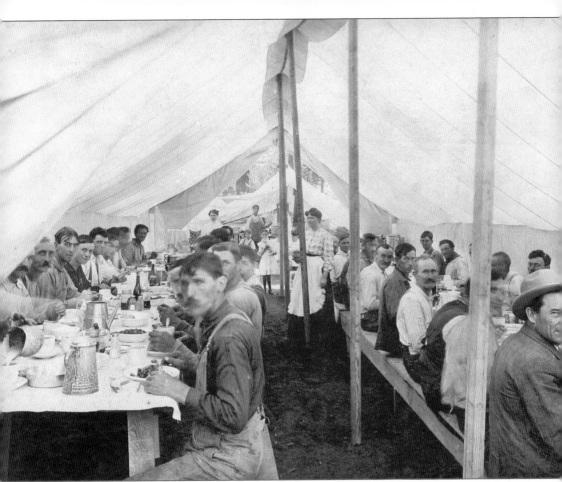

These loggers are eating in the dining tent at a logging camp. In the rear, the cook is stirring the pot as two waitresses serve. Apparently the boy and girl in the back of the tent have brought their pet for a snack. Often the best loggers worked in the camp whose cook had the best reputation.

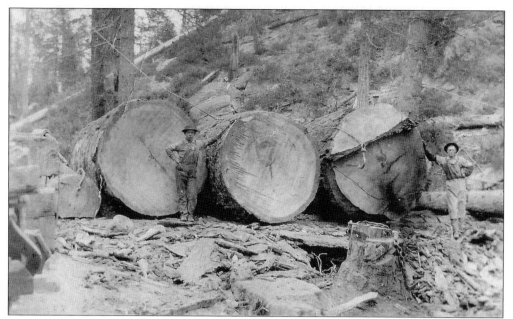

In 1913, these large logs await loading onto a flatcar at a landing in North Valley. The hook on the end of the cable from a steam donkey hangs over the front of the log to the right. It will be used to first roll the log on the left up onto the car. Cloyd Pearce is on the left and Jim Inks (?) is on the right.

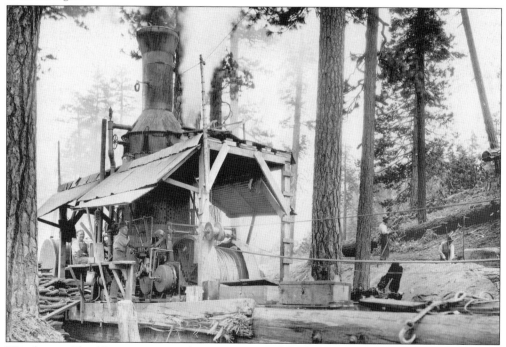

Winch man Cloyd Pearce operates this steam-powered donkey engine. Behind him is the fireman who fires the boiler. Donkey engines were used in many sides of the logging operation. Here it is "yarding" (dragging) logs to a landing where they will be loaded on flatcars and taken to the mill. The heavy cable is running from the winch to a spar tree that is out of sight.

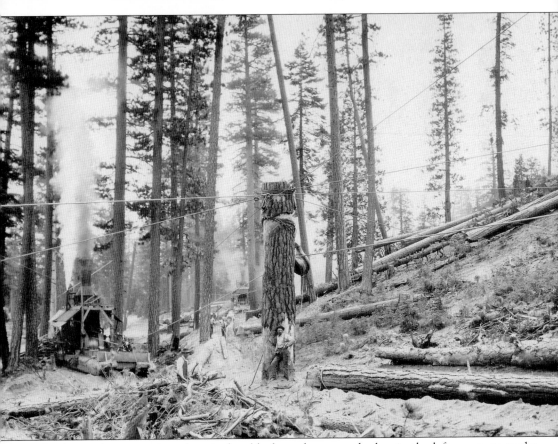

In this yarding operation, the winch cable from the steam donkey in the left rear runs to the huge pulley block, hanging on the right side of the spar tree in the center. The spar tree has been notched by the cable securing the pulley as it rotated so logs could be pulled to the landing from different locations in the forest.

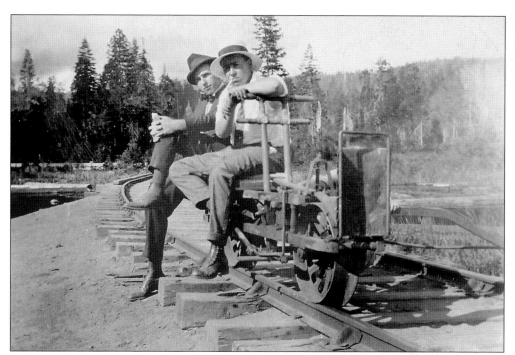

Delmark Head and Harry Malloy rest on a hand-pump car which probably brought them to town. Both men were loggers, and must be all "duded up" for a "big time" in Stirling City in 1916.

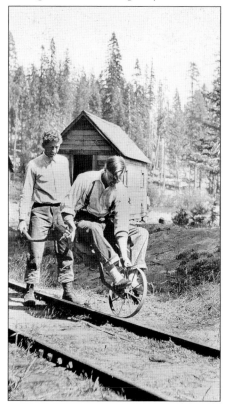

"Messin' around" is what these young men did in 1914 when not risking their lives logging in North Valley. Riding in the wheelbarrow, Cloyd Pearce does not look too sure of what Bill Dutter is going to do as he is pushed along the rail.

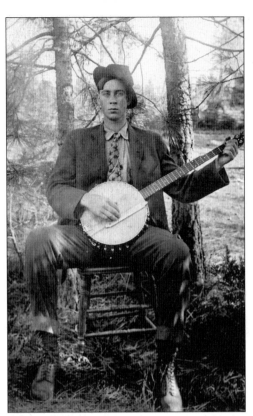

Shown here when he went to work for Diamond Match at age 18, Dana Bailey could pick a mean banjo. He did every logging job there was in the woods. In 1923, he became the "Bull of the Woods," or logging superintendent. As superintendent, he always wore a starched, white shirt, even in the woods.

In 1915, surveyor Frank Compton stands behind his transit. The man on the left holds a stadia board that was used to determine elevation. The man on the right holds a tape or "chain" for measuring distance. Diamond Match survey crews surveyed rail lines, roads, boundary lines, and more.

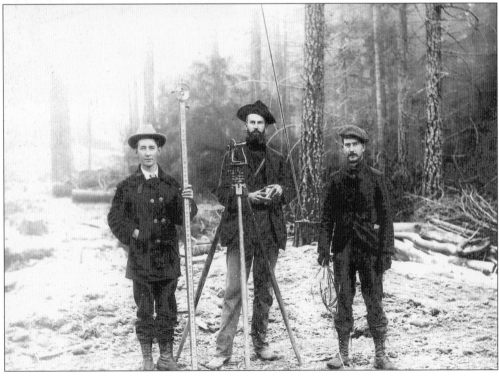

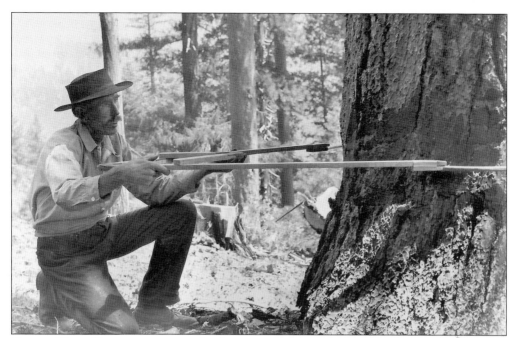

Cruiser Albert Green is measuring the diameter of a tree some time between 1910 and 1913. A cruiser is a timber estimator who determines the quantity and quality of a stand of timber.

The two men in this out-of-focus but rare photograph are "greasing the chute" (riding down a log chute while applying grease to it). Chutes were an early way to get logs out of the forest to a landing where they were loaded onto railroad flatcars for transportation to the sawmill. Even though the chutes were greased, the noise the logs made reverberated throughout the forest.

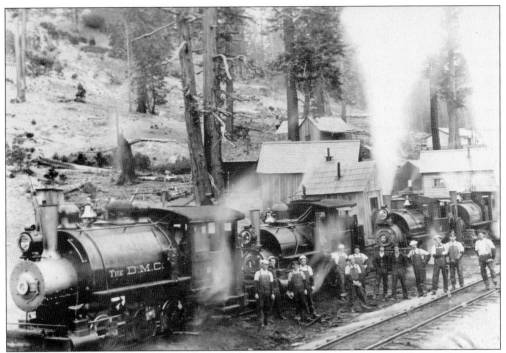

Diamond Match meter-gauge saddletanker engines Nos. 6, 1, 2, 4, and 3 (out of picture) are lined up with their crews at Ramsey Bar on the Kimshew Line, *c.* 1912.

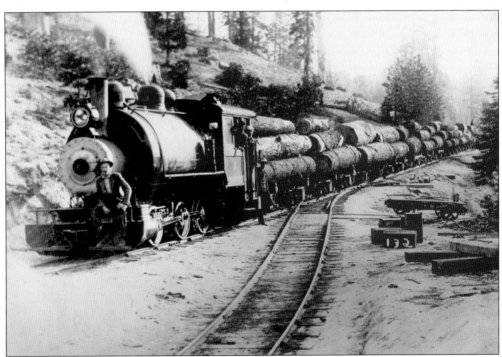

A meter-gauge logging train headed by Engine No. 6 pulls into Ramsey Bar. Frank Compton, later "The Bull of the Woods" (logging superintendent), sits on the front of the engine.

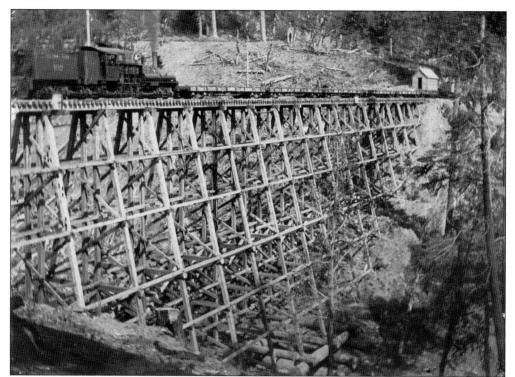

Shay No. 102 pushes empty log cars across Cold Creek Trestle near Transfer Landing. This trestle was 400 feet long, 95 feet high, and contained two million feet of lumber.

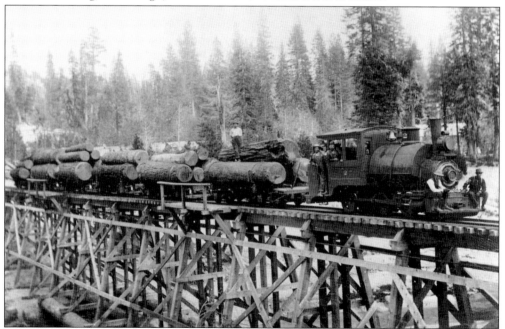

Saddletanker No. 2 and its crew pause for a photograph on the Ramsey Bar trestle over Kimshew Creek. The meter-gauge railroad reached Ramsey Bar in late 1909. Some of the logging camp buildings are visible behind the train.

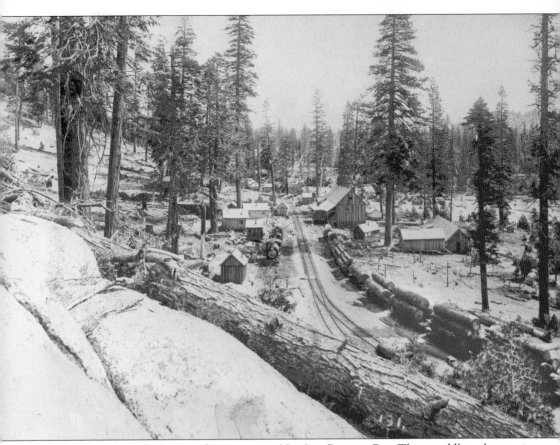

Pictured in the fall of 1910 is logging camp No. 3 at Ramsey Bar. Three saddletanker engines wait on the siding to the left of the main narrow-gauge line, and loaded flatcars are ready to be pulled to Transfer Landing on the siding to the right.

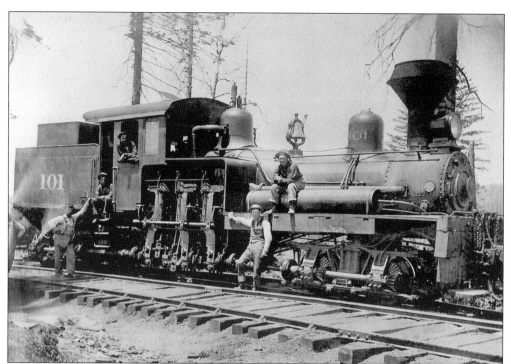

Because logging railroads have tight curves, large logging engines are gear-driven and quite different from the familiar large-wheeled engines that run on regular rail lines. Gear-driven engines have three cylinders located on the right side of the boiler connected to a horizontal, articulating, drive shaft with universal joints that turn geared drive wheels on trucks that swivel. Shay engines were the most common type and Diamond Match had four. The Willamette engine was larger, heavier, and more powerful. The top picture is of Shay No. 101 that has one truck under the engine and another under the tender behind the cab. The bottom picture is of Willamette No. 104, which has one truck under the front of the engine, another under the cab, and a third under the tender.

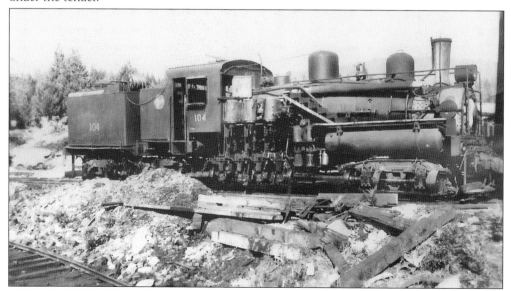

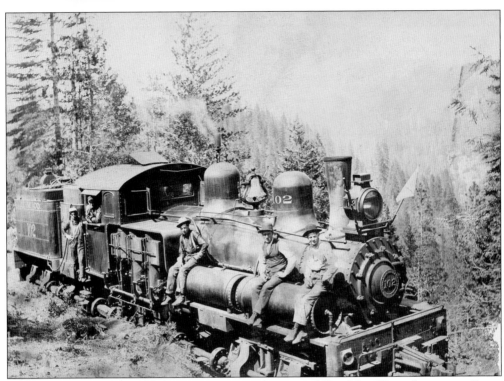

The crew of Shay No. 102, with engineer E. L. Myers in the cab, poses for a picture near Stirling City. The other guys are just along for the ride. The three vertical steam pistons connected to the horizontal drive shaft are quite evident.

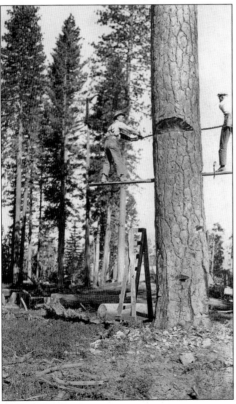

Two fallers (log buckers) bring down a huge pine tree. They have notched the tree and stand on "spring boards" that enable them to stand wherever they want. They are using a two-man cross-cut saw affectionately known as a "misery whip," called that due to the back-breaking labor its use involved.

Timber! A big one falls. This pine tree was cut down by a large, two-man chain saw that was powered by electricity from the caterpillar tractor on the right.

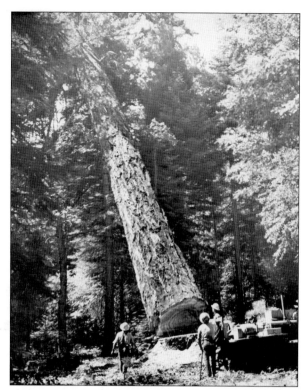

A McGiffert steam-powered loader, called a "jammer," was moved on the railroad track to a landing and then jacked up to straddle the track. Empty flatcars were pushed from behind to a position beneath the crane. A log, laying along side the track, was then picked up and lowered onto the flatcar.

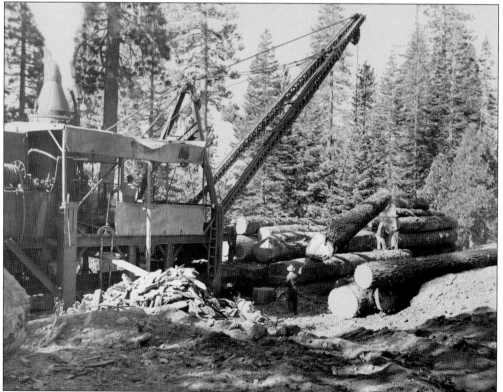

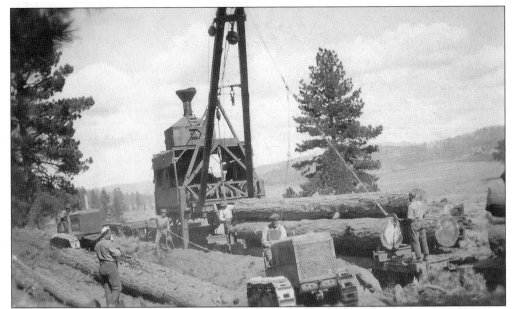

This gasoline-powered American "jammer" was a later type of loader. Operated by Harold Beavers, this one has lowered the log onto the flatcar. The large hook in the end of the log is about to be removed by the "hooker." The caterpillar tractors are dragging logs to be picked up by the jammer.

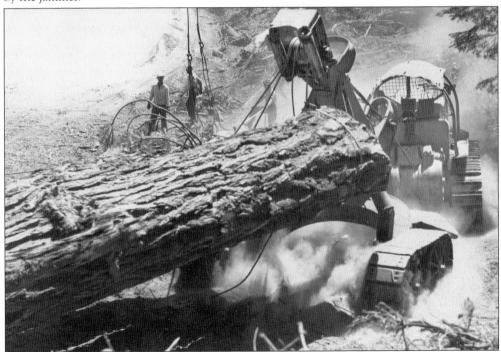

A caterpillar pulls a tracked arch to a landing. One end of the log is snubbed to the arch while the other is skidded along the ground. "Hookers" wait to set dangling choker cables around the log for a crane to hoist it onto a logging truck. On smaller logs, hooks were used instead of chokers, hence the name "hookers."

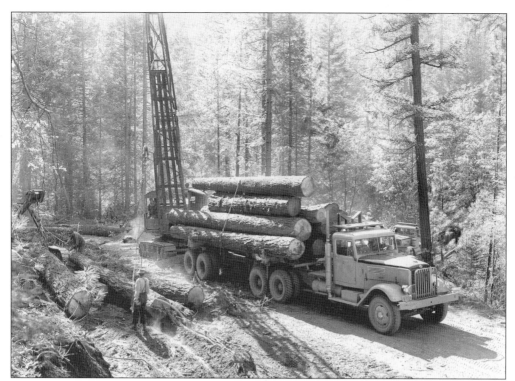

Having just loaded the truck, the crane operator lowers a choker cable to a hooker while another hooker frees a choker that snubs several logs to an arch, the head of which is visible to the left. The crane came into use once truck logging commenced.

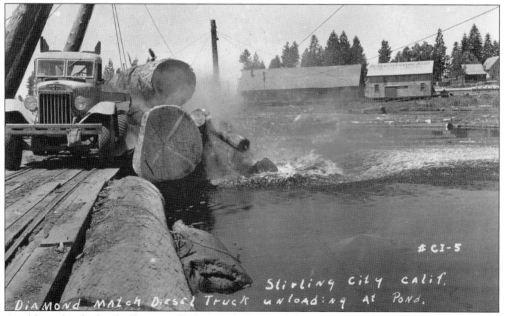

A cable under the load of logs is pulled up by the spar pole looming over the truck rolling them into the mill pond. The large "brow log," seemingly suspended over the edge of the pond, is fastened to the roadway. It prevents logs being unloaded from rolling back under the truck.

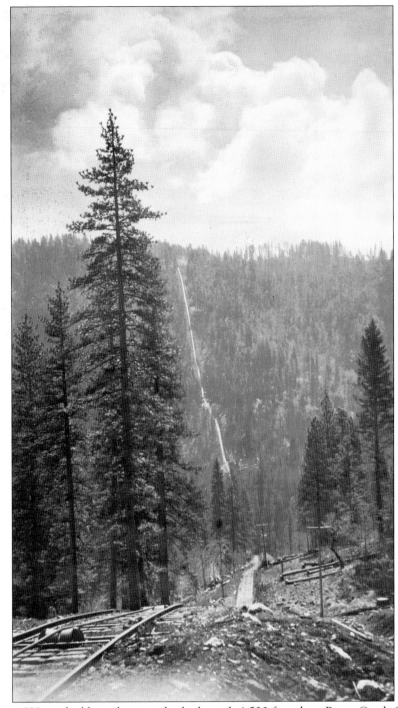

In the late 1920s, a double incline was built through 1,500-foot deep Butte Creek Canyon to get logs from West Branch to the Stirling City mill. Standard-gauge flatcars loaded with logs were lowered by a winch down the west side and then pulled up the east side by another winch. Unloaded flatcars went the opposite direction. Shay engines were also moved through the double incline. Note the winch cable between the tracks on the left.

This flatcar loaded with logs is being winched up on the east side of the double incline. The angle of the tracks was over 60 degrees in some spots.

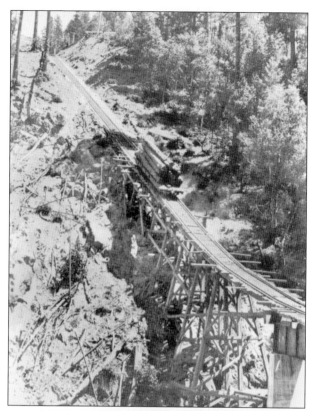

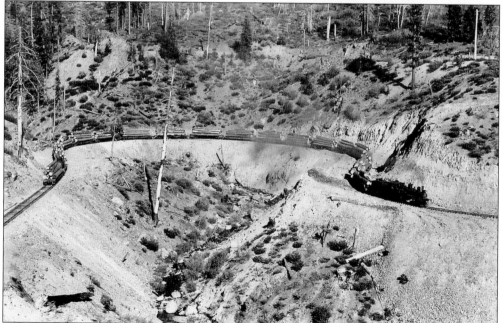

Engine No. 104 pulls 18 log cars and a tank car (in front of last log car) through the first curve of the Bull Creek Loop. Actually an S curve, it is typical of the tight curves on the standard-gauge Butte Meadows to Stirling City rail line.

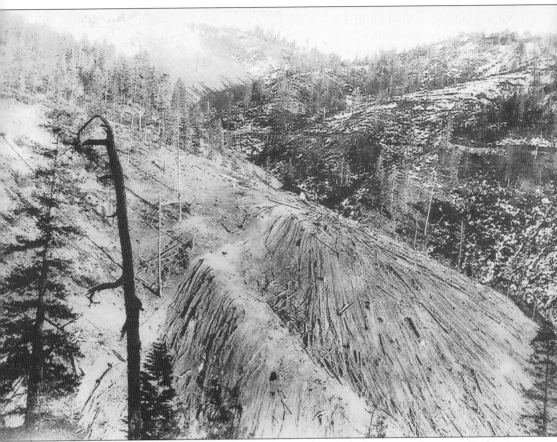

The ridge in the foreground, probably above Bottle Creek, has been clear-cut. Early pictures show that this was a common practice. However, through natural regrowth and in later years, reforestation, the forest has come back. The Stirling City–Butte Meadows rail line can be seen running along the hills in the background.

In 1949, a "hard luck" engine, Willamette No. 104, almost went into Bottle Creek while hauling log-laden flatcars from Butte Meadows to Stirling City. It was "on the ground" (derailed) often and in three serious accidents including this one. It also rolled over when a section of road bed slid from under the tracks, and in 1943 it was nearly destroyed when three runaway flat cars collided with it, killing two men.

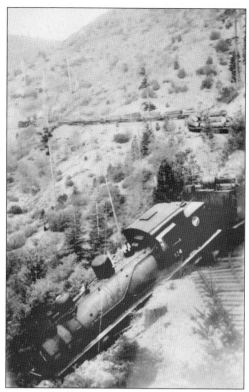

This replica Baltimore & Ohio engine was used in the 1938 MGM movie *Stand Up and Fight*. Scenes were shot on a Diamond Match spur line in Butte Meadows. Pictured in the foreground, from left to right, are Horace Hough, MGM assistant director; Dana Bailey, Diamond Match logging superintendent; Richard Coglan, Diamond production manager; Rexford Black, California Forest Protective Association; and Richard Rossen, MGM director. From left to right on the engine are fireman Johnny Strine and engineer Lawrence Segle.

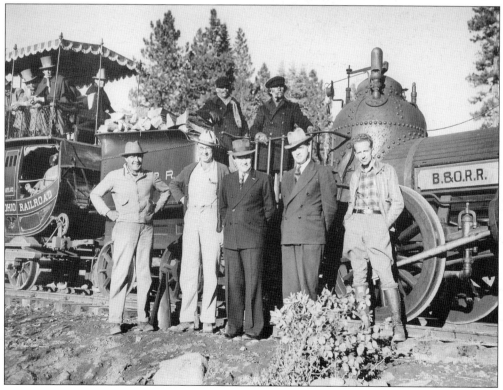

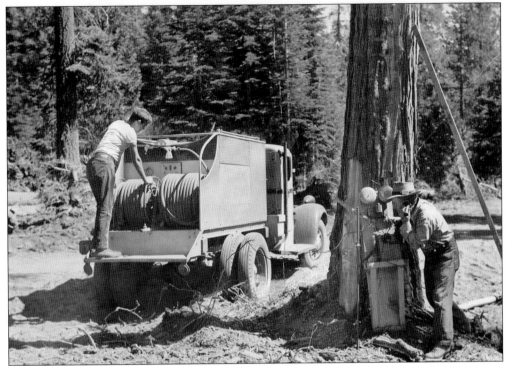

While one fireman works on the slide-on tanker fire truck, the other calls in on the telephone to the Stirling City operator. Diamond Match fire crews attempted to control wildland fires, but if they could not, the Forest Service and/or California Division of Forestry and Fire Protection were called. On large fires, sawmill and logging camp crews nearly always were called out for duty on the fire line.

The buildings at Camp No. 1 at West Branch, built on skids, were reused in every logging camp and carried to the site on flatcars. Using a donkey engine or jammer they were off-loaded and skidded into position along camp streets. The uneven rails down the street were intended to carry the flatcars loaded with houses, not logs.

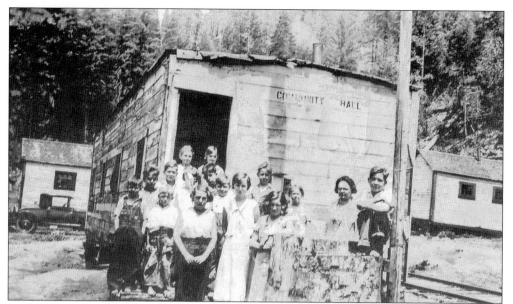

In all its major logging camps, the company provided a portable (like most of the other buildings) schoolhouse and hired a teacher, seen second from the right in this picture of the school at West Branch Camp No. 1. One teacher taught most grades, and high school students were sent to Chico.

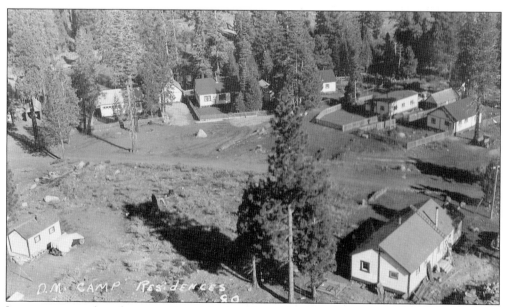

Larger camps, such as the one at Butte Meadows, lasted for several years and acquired a permanent look. In this 1950s picture, picket fences and garages are visible. Individual gardens also were common. The camp included 67 cabins, warehouses, shops, a cookhouse/dining hall, and had electric power supplied by generators. Opened in 1936, it closed in 1956 when the company ceased logging.

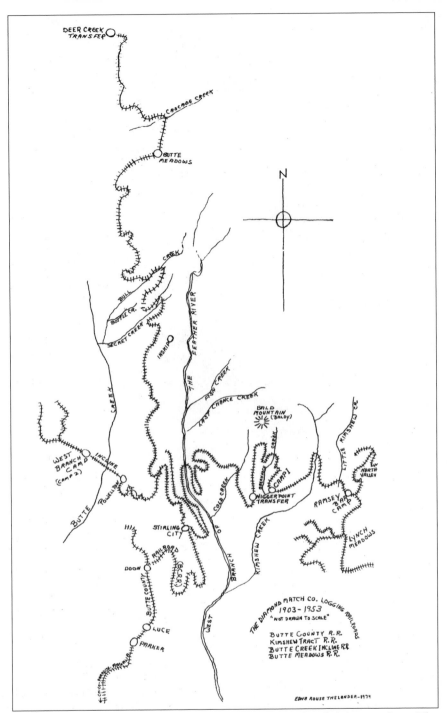

Diamond Match's extensive logging railroad began in 1903 and ended 50 years later. The tracks were standard gauge except for those built from Nigger Point Transfer eastward into the Kimshew country around Ramsey Bar. This line was meter (narrow) gauge and ran between 1909 and 1916. The Stirling City–Butte Meadows line was the last to operate, closing in 1953 when it was converted into a logging truck road.

Seven

STIRLING CITY

Stirling City was named for a boiler. Pressed to come up with a name for the new mill town, Fred M. Clough, Diamond Match's Pacific Coast manager, said, "Let's call it Stirling." He got the name from the boilers that produced steam to drive the 1,200-horsepower Corliss steam engine that powered the sawmill. "Stirling Consolidated" was cast into the face of the steel boilers. The city proper may have come later, as Mr. Clough envisioned more than just a mill town. At an elevation of 3,525 feet, about 12 miles up the ridge from Magalia, he saw it as an ideal summer resort because of its scenery and mild, invigorating climate. Unfortunately, nothing ever came of this grand idea.

Land was cleared and construction started on both the town and sawmill by mid-1903. Shortly thereafter, people were living in the new houses and patronizing the new commercial establishments. Never a typical company town, anybody could live in Stirling City, but they bought lots for $75 to $250 from the company, or rented houses owned by the company or its officials. Private businesses were encouraged, but typically they also had to rent company-owned buildings.

Although Diamond Match did not operate a company store in the true sense, company officials did. They privately incorporated the Stirling Mercantile Company, whose purposes included running a general mercantile business, dealing in real estate, establishing a bank, and brokering insurance, along with operating hotels, restaurants, boardinghouses, and dealing in "spiritous liquors." From the start, Diamond Match apparently made little, if any, profit from logging and mill operations. But company officials and favored shareholders did make significant profits from owning the town, buildings, and some of the businesses, especially the Mercantile Company,

The most notable of these commercial operations was the three-story Stirling Mercantile Company Building on Laurel Street. One could buy almost anything in the general store on the first floor. Additionally the Mercantile Company made most of the purchases for Diamond Match, taking a middleman's cut. It also sold supplies to the logging camps and men who worked there, as well as to company-owned boardinghouses.

Diamond Match officials also incorporated the Stirling City Bank. Profitable from the start, it handled the $36,000 Diamond Match payroll as well as the $150,000 payroll for workers building the Western Pacific Railroad, up the Feather River Canyon. Most of this money was spent in Stirling City when the loggers "hit town," when railroad workers came to town for their "payday spree," and when families living in town or in logging camps needed staples.

Liquor, prostitution, and gambling were major money makers. All deeds on lots sold by Diamond Match had a clause prohibiting the sale of liquor—except one that was owned by the Mercantile Company, of course. The Red Devil saloon was actually painted red, perhaps with paint left over

from the red sawmill. Next door was the two-story "White Angel," a bordello incongruously painted white. While it was not owned by the Mercantile Company, owner Irene King, a "soiled dove" from San Francisco, certainly had approval to operate from the Mercantile Company. Gambling ran so hot and heavy on paydays that it attracted professional gamblers on those days.

There were numerous other less notorious businesses, also not owned by the Mercantile Company. They included Suggett's haberdashery and sundry store, Nash's moving-picture theater, Nash's notions store with post office in the rear, Spangler's boardinghouse, and King's pool hall (yes, "soiled dove" Irene King), to name just a few. Visitors soon found that "the place to stay" in Stirling City was the Reynor Hotel.

Most of this commercial activity came to an abrupt halt on a hot, windy day in April 1931. A fire, origin unknown, destroyed most of the business district, including over 20 homes and numerous cabins. The town survived, and many buildings were rebuilt, but the business district reappeared on a smaller scale. The Mercantile building was gone, replaced by a smaller store that was leased to merchants.

Stirling City was just too stubborn to die and become a ghost town. It died twice, the first time in 1958, when Diamond Match ceased logging and closed the sawmill, and the second time in 1974, when a stud mill that had operated for 10 years closed. The town has resurrected itself and today is a community where longtime residents live in some of the old homes along with newcomers in modern residences. The only business of any size is Sierra Pacific Industries, which logs the old Diamond Match lands. These days, however, logs are trucked to a sawmill at Red Bluff. The nearest store of any size is 12 miles down the ridge in Magalia.

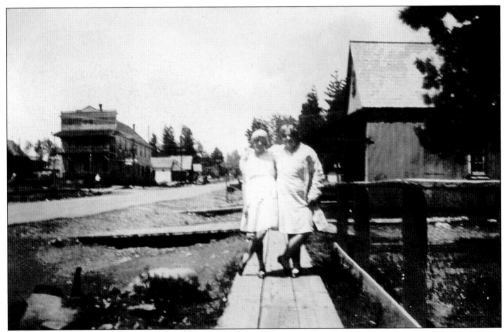

This rare shot of central Stirling City shows two ladies "on the boardwalk" on Laurel Street. Their attire indicates that this photograph was taken in the late 1920s or the early 1930s. Most of the central streets had boardwalks on either side, which were an absolute necessity during the wet season, when dirt street turned to mud. The large, two-story building on the other side of the street is Spangler's boardinghouse, which had 30 rooms and was built in 1903. Louis Spangler was a carpenter and hostelier who helped build the sawmill and other Diamond Match Company buildings. It burned in the 1931 fire and was rebuilt on a smaller scale. Nash's moving-picture theater is behind them on the right.

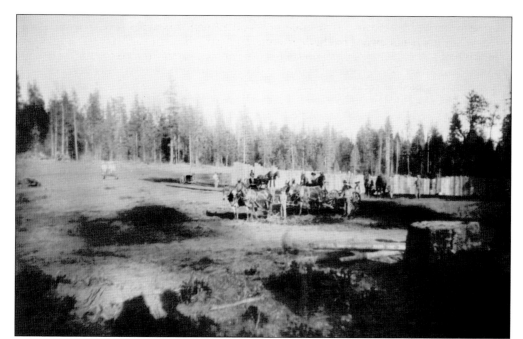

After having purchased an initial 69,000 acres in the mountains of Butte, Plumas, and Tehama Counties, the Diamond Match Company proceeded with plans to build a mill town. By mid-1903, men were clearing land where Stirling City would be built.

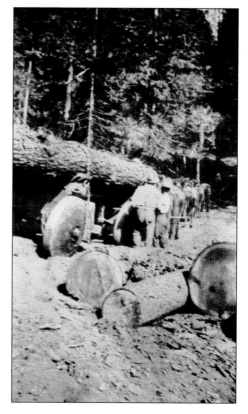

These logs are being hauled to the Bennett sawmill, near where the mill pond at Stirling City would eventually be. Earlier, lumber for the town's early buildings was cut at a sawmill in Doon, several miles down the ridge. This 1903 picture shows a rather crude wagon carrying the logs.

Samuel Vandegrift was one of the first Butte County men hired by Diamond Match. He was an experienced timber cruiser (estimator) and "fronted" for the company to circumvent land speculators. In this picture, Sam Vandegrift (left), has just arrived at his hunting cabin at Alder Creek with J. B. Carr and G. W. Short.

The first house on the hill, probably on Oak Street, was built in 1903 by Samuel A. Vandegrift. He helped lay out the town and owned a number of lots on which he built houses for rent and for sale. It is said that he always went about with a brace of derringers, even when collecting his rents.

In March 1906, this was the road that got you to Stirling City. It was typical of the times, but not exactly what you would call a highway.

This picture was taken during the construction of the boiler room for the sawmill, which can be seen in the background. The boilers were insulated in the brick structure. The furnace openings are visible at the bottom. The bricks were made locally from a clay deposit in Long Ravine near Stirling City.

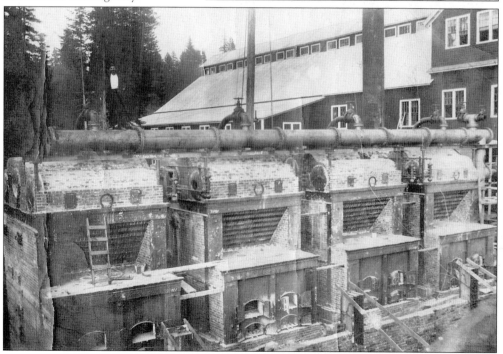

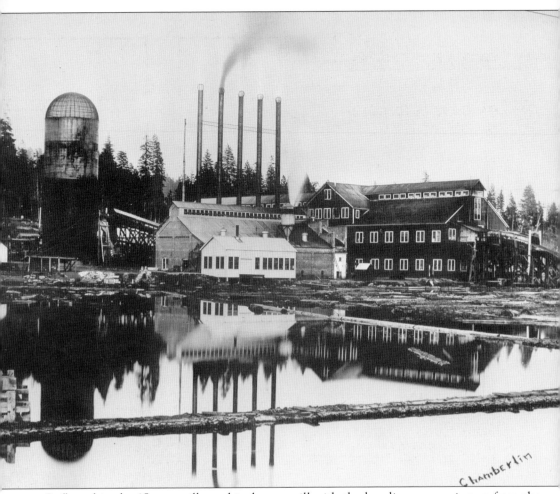

Reflected in the 15-acre mill pond is the sawmill with the log slip-way curving up from the pond. The large building with five smokestacks houses boilers. The town name was taken from the Stirling Company that manufactured the boilers in this building. The sawdust incinerator is on the left.

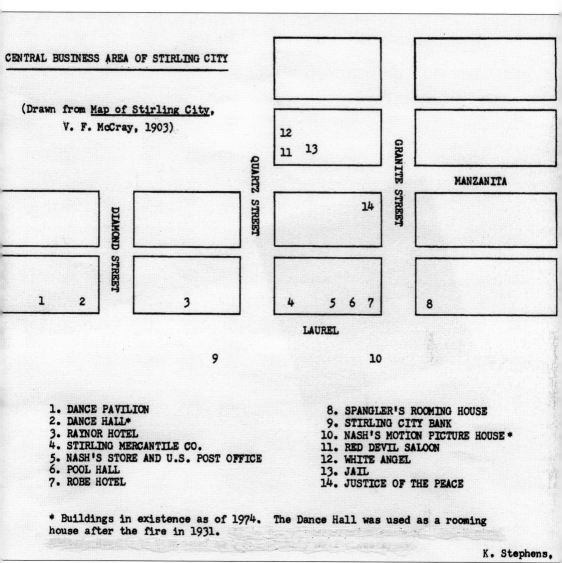

CENTRAL BUSINESS AREA OF STIRLING CITY

(Drawn from Map of Stirling City,
 V. F. McCray, 1903)

MANZANITA

QUARTZ STREET

GRANITE STREET

DIAMOND STREET

LAUREL

1. DANCE PAVILION
2. DANCE HALL*
3. RAYNOR HOTEL
4. STIRLING MERCANTILE CO.
5. NASH'S STORE AND U.S. POST OFFICE
6. POOL HALL
7. ROBE HOTEL

8. SPANGLER'S ROOMING HOUSE
9. STIRLING CITY BANK
10. NASH'S MOTION PICTURE HOUSE *
11. RED DEVIL SALOON
12. WHITE ANGEL
13. JAIL
14. JUSTICE OF THE PEACE

* Buildings in existence as of 1974. The Dance Hall was used as a rooming
house after the fire in 1931.

K. Stephens,

This map shows the locations of the major buildings in Stirling City before the April 1931 fire
that destroyed most of the business section. The Raynor Hotel actually burned in a second fire
a month later.

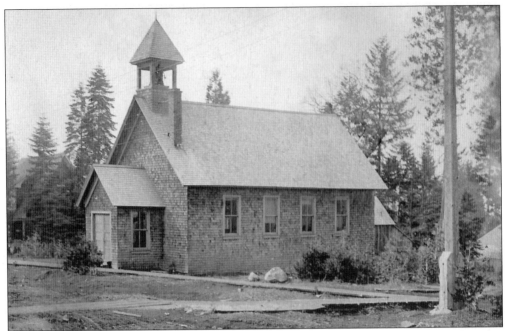

The Little Brown Church was built in 1904–1905 on Manzanita Street. Originally a Presbyterian church, today it is used for such functions as bible classes. Although she lived in Chico, the very religious Mrs. John (Annie) Bidwell provided the money and was a driving force behind its construction. She also tried to close the saloon and brothel in town.

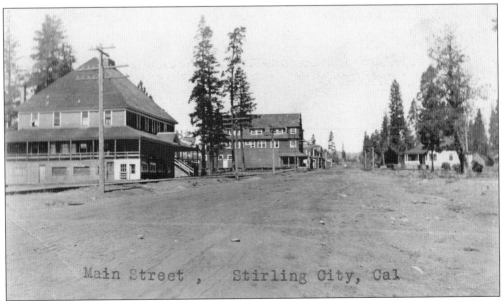

Looking north up an unpaved Laurel Street, the Raynor Hotel is on the left. Next is the three-story mercantile building in which the first floor was a general merchandise store, the second an Odd Fellows Hall, and the third offices and rooms. Beyond is the rest of the business district and across the street is the bank.

These houses on Oak Street are typical of those built in the very early days of the town. Electric power was furnished by the mill, hence the power pole between the houses. Steam heat was also furnished to some homes, and the town had the first sewer system in Butte County.

The Crum home as it looked in the winter of 1905. Mrs. Crum and her two-year-old daughter Dorothy May stand next to Ralph Crum. Next to him on the right are Mr. and Mrs. De Mans. The Crum house was next door to the De Mans's house and still stands on Manzanita Street.

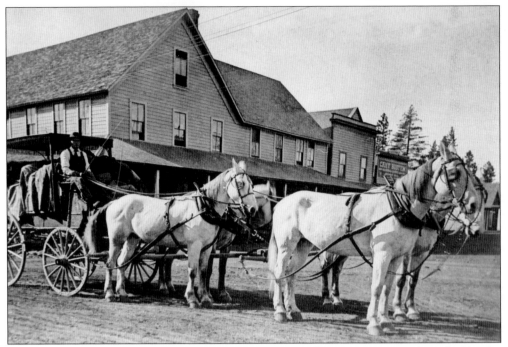

This 1906 picture was taken at the intersection of Laurel and Granite Streets. The Robe Hotel is in the background with Simmens and Suggett's Clothing store (CAN'T BUST 'EM on the false front) next. Can't Bust 'Em was a brand of work clothes.

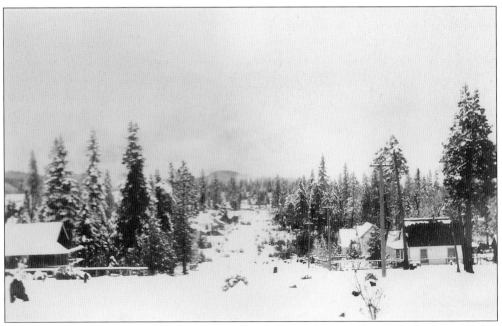

This winter view looks down Oak Street to the south. Taken in the early 1900s, this image makes it clear that few houses existed on the hill in the northern part of town.

In 1910, Bill Spring's bedroom in a Stirling City boardinghouse looked like this. Who the young lady is or what she is doing there is not known.

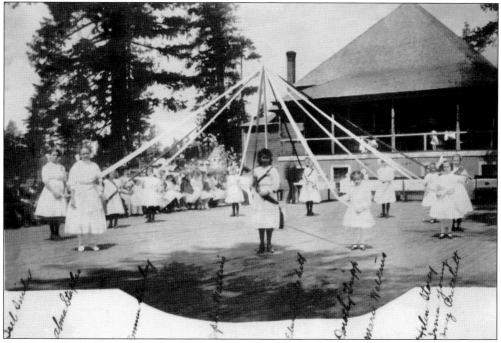

A 1910 May Pole Dance is held at the Dance Pavilion that was located at the south end of Laurel Street. Pictured, from left to right, the young ladies are Isel Snider, Alma Staples, Emma Stanley, Orpha (?) Watkins, Pritchett, Dorothy Tripp, Marci Watkins, Helen Storey, Irma Young, and Inez Pritchett.

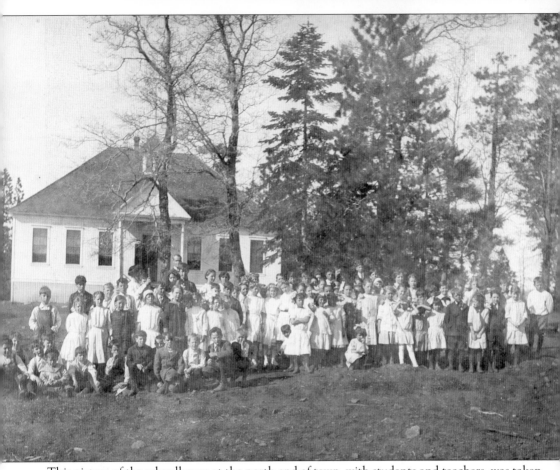

This picture of the schoolhouse at the north end of town, with students and teachers, was taken about 1908. This was no one-room schoolhouse. Diamond Match did well by its children.

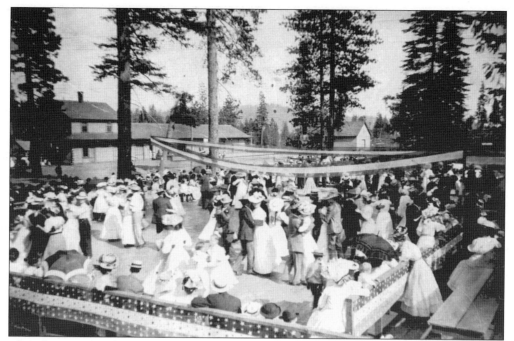

This photograph, probably taken in 1910, shows a Fourth of July dance at the Dance Pavilion. There are several pictures of large numbers of "dressed-up" folk disembarking from an excursion train from Chico on July 4, 1910, at the Stirling City Station (see the upper photograph on page 37). It seems likely that many passengers were coming to this dance.

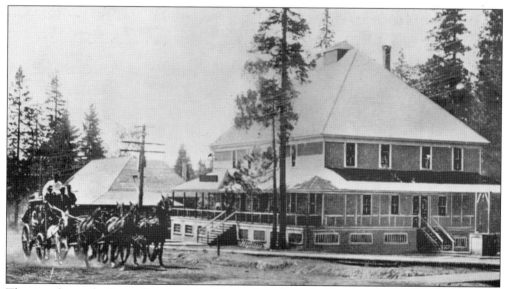

The stage leaves for Prattville, where it will travel north up the Humbug Road through Powellton, Inskip, Chaparral House, Butte Creek House, over the Humbug Summit, and on to Prattville. The "place to stay" in town, the Raynor Hotel, is in the background. It burned a month after the April 1931 fire.

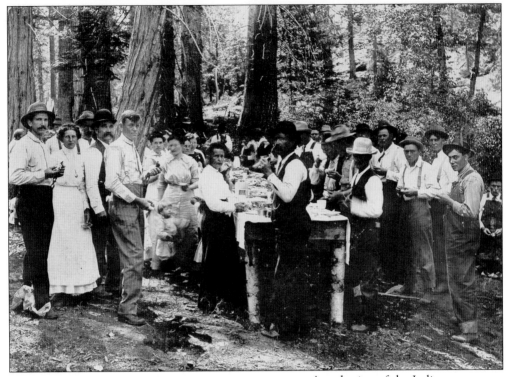

A gathering of the Italian community is shown in this photograph. The Italian loggers lived with their families in what was called "Little Italy" or "Dago Town." It was south of the mill pond. Emilio Merlo is in front of the table in the black hat, looking at the camera. Years later, Harry Merlo, one of his nephews, purchased the land and created Merlo Park in honor of his mother, Clotilde.

Mrs. Samuel (Evaline) Vandegrift is starting down Oak Street on March 29, 1914, with snow that was 53 inches deep. Called snowshoes in those days and widely used during the Sierra winters, she is wearing what later would be called skis. The pole was used for balance, but looks heavy enough to fend off bears.

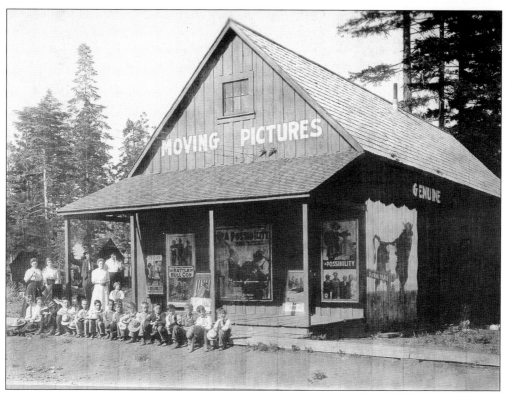

This photograph from the summer of 1914 shows what the first community center, called Horton's Hall after the builder, looked like. Later it was known as Nash's Moving Picture Theater, a favorite place to go for young and old alike.

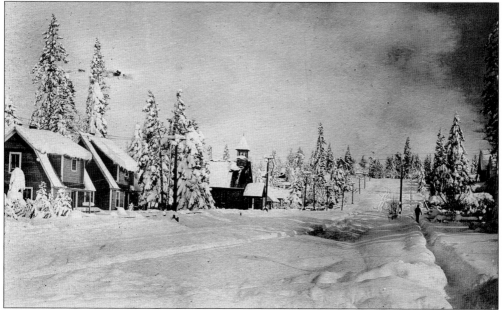

The Little Brown Church stands out at center left of this winter picture, looking to the north on Manzanita Street.

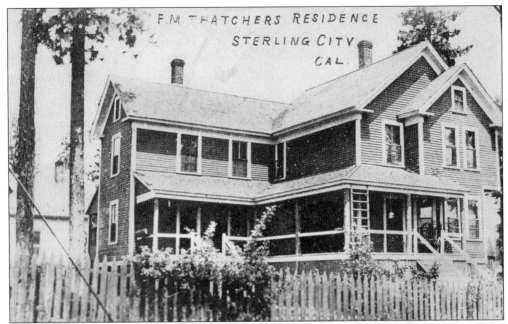

While building the town in 1903, Diamond Match constructed this home on Laurel Street for its Superintendent of Woods and Sawmill Operations. In the early 1920s that was Frank Thatcher. J. Frank Nash, who supervised building the town, was its first resident. Today it has been restored and is a residence. It had steam heat and electricity supplied by the sawmill power plant.

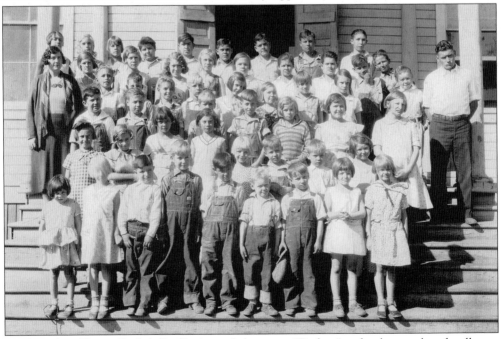

On the right is Horace Brakebill, affectionately known as "Brakey," and a class on the schoolhouse steps probably in 1932. Starting in 1927, Brakey was a teacher in Stirling City for nearly 40 years. The new schoolhouse (built in 1951, but no longer used) was named after him. The woman on the left is probably Miss Vogelsang, another teacher.

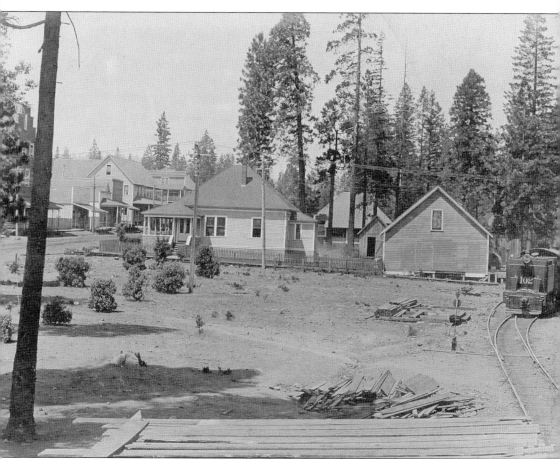

The Stirling City Bank in the center of this photograph was later used as Dr. Homer Rue's office and surgery. Across Laurel Street is the Stirling Mercantile Company. The large building down the block with the window in the gable is the Robe Hotel, and the false-front building beyond is Spangler's boardinghouse. On the right, Shay No. 102 is on the tracks that curved around to the mill.

The Mount St. Agnes Hospital can be seen on the hill in this 1930 picture south of Laurel Street. Nash's Movie House is on the left. Beyond the three-story mercantile building is the Raynor Hotel and the dance hall. On the near side are Moliter's bakery, William Nash's post office and sundry store, and Irene King's pool hall. She also owned the White Angel, a brothel, where she and her "soiled doves" made far more money.

A Shay engine is moving up the track that curved around to the sawmill that is behind the photographer. This photograph was taken before the fire in 1931 as the Stirling Mercantile Company building can be seen on Laurel Street.

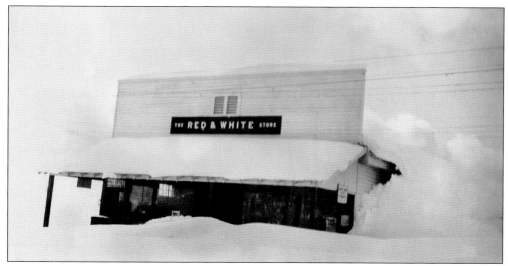

Musselman's Red and White Store was on the corner of Laurel and Quartz Streets, on the site of the Stirling Mercantile Company that was destroyed in the 1931 fire. The new building, constructed after the fire, was rented to different merchants over the years.

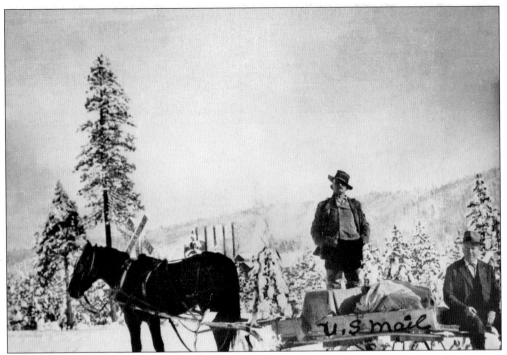

The U.S. mail must go through! In Stirling City, John Geiger (center) saw that it did even in the winter, as evidenced by the mail bags on his sleigh. The five smokestacks of the sawmill are visible in the background behind the horse.

The Mount St. Agnes Hospital was built in the early 1900s on the hill at the south end of Laurel Street. It was operated by the Catholic order Sisters of Charity and supervised by Sister Augustine, who is standing on the porch to the left. The building also served as an orphanage. In the 1950s, it was torn down.

In earlier years, they played baseball, but by 1938 the league was playing softball. Here the Stirling City team, mostly Diamond Match employees, is ready for a game at the Chico Fairgrounds. Pictured, from left to right, are Ray Orner Sr., Harold Penico, Frank Anderson, Ray Orner Jr., Elmer Martin, Don Orner, Tom Mead, Bobby Wilson (bat boy), David Sheley, Glen Rowe, Bud Asher, Newt Murphy, Ed Scott, and Pop Sheley.

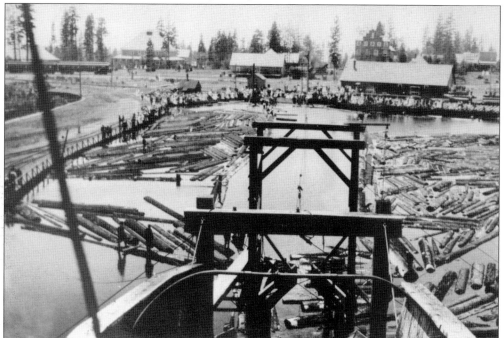

This picture was taken before 1931 from the sawmill at the top of the slip-way. Some of the buildings of Stirling City are in the background. Judging by the number of people around the mill pond, a "logger's jamboree" must be in progress.

As a log enters the mill, the draw saw makes the first cuts that determine the length of the finished lumber. Pictured, from left to right, are James Delaney, Foster Washburn (behind saw blade), William V. Meyer Jr., C. G. Josephson, and Albert Irons.

After the disastrous 1931 fire, the business district was rebuilt. This *c.* 1940 photograph shows where the Raynor Hotel stood, replaced by the Forest Service Ranger Station residence and small office. Next is the automotive garage that was owned and operated by various people. Across Quartz Street, where the mercantile was, a smaller store was built and leased to various merchants including A. C. Musselman, Truman Blair, and Kilpatrick and Sons.

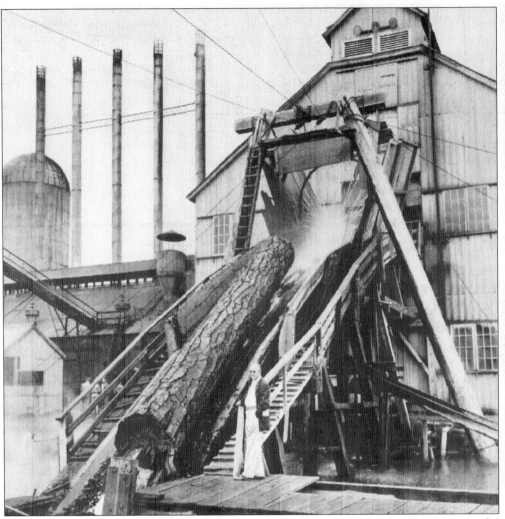

The last log to be processed by the mill before it closed on January 31, 1958, moves up the slip-way into the sawmill from the mill pond. In 54 years, the mill processed 1.809 billion board feet of lumber.

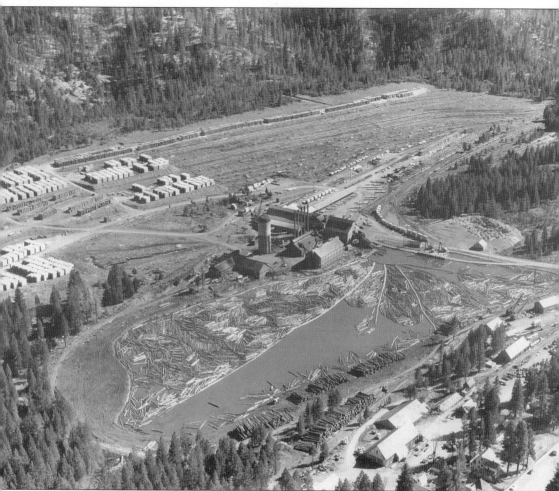

This 1953 photograph shows how the Diamond Match Stirling City mill looked throughout most of its 54 years. In the mill complex, the long building in the rear is the sawmill, and the light-colored building next the mill pond is the where boiler fuel was stored. The building with the five smokestacks housed the boilers, the L-shaped building with the dark roof is the machine shop, and the tall cylindrical structure is the sawdust burner. The building that housed the 1,200-horsepower Corliss steam engine that provided power is between the boiler room and the sawmill. Finished lumber is stacked to dry in the field behind the mill complex. In the lower right corner is Laurel Street in Stirling City.

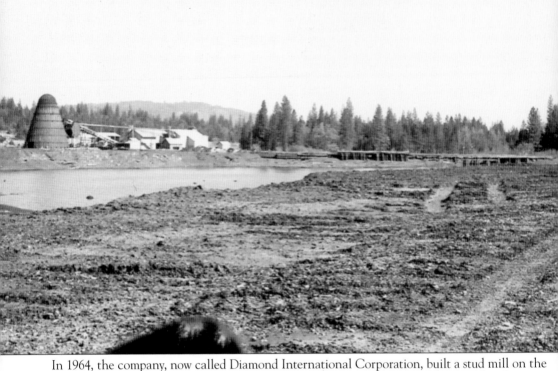

In 1964, the company, now called Diamond International Corporation, built a stud mill on the site of the old sawmill. The old mill pond is in the center of this 1974 photograph taken just before the mill closed. Powered by electricity and employing 24 men, the mill operated for 10 years, after which Stirling City was out of the sawmill business for good.